THE COMIC BOOK LESSON

THE COMIC BOOK LESSON

A Graphic Novel That Shows You How to Make Comics

Mark Crilley

WATSON · GUPTILL

CALIFORNIA | NEW YORK

INTRODUCTION

I had this idea: to teach people how to make comics by presenting lessons in the form of an actual comic book story. The two things seemed like a match made in heaven, but showing someone how to make comics is no small task. Even the simplest comic involves not only writing and drawing, but also designing characters, laying out pages, and wrestling with the surprisingly tricky matter of knowing where to put all those speech bubbles.

Unfortunately, many aspiring comic book creators get distracted by matters of style, focusing all their energies on learning how to draw particular things such as superheroes or manga characters. But you can't make a good comic if you don't grasp the basic nuts and bolts of how comic book storytelling works: that delicate dance between words and pictures that occurs the moment you begin putting one panel next to another.

So, no, this book won't show you how to draw specific things, or tell you what kinds of ink pens or software you should buy. Because you can't make great comics simply by buying a bunch of stuff, or by learning how to draw awesome-looking capes.

It really comes down to learning how to *think* the way a comic book creator does. Each new panel presents you with endless options for what you're going to show to the reader, and how you're going to show it. Your job is to consider those options, weighing one against the other, and then choose the one that will best convey that next little beat of the story. This is at the heart of every comic anyone has ever made, whether it's about intergalactic aliens, the French Revolution, or a couple of dudes sitting around playing cards.

My hope is that you're at least a little like Emily, the main character in this story. She's not looking for drawing lessons, or for a list of things she has to buy. She's got her sights set on something much more fundamental than that: How do you transform an idea that's stuck in your brain into an actual comic book story? If that's something you're eager to learn, then read on. This book is for you.

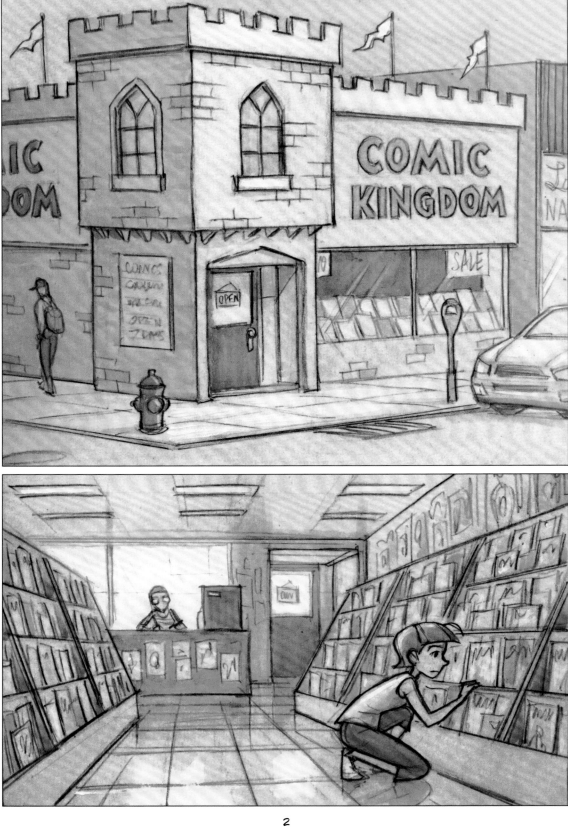

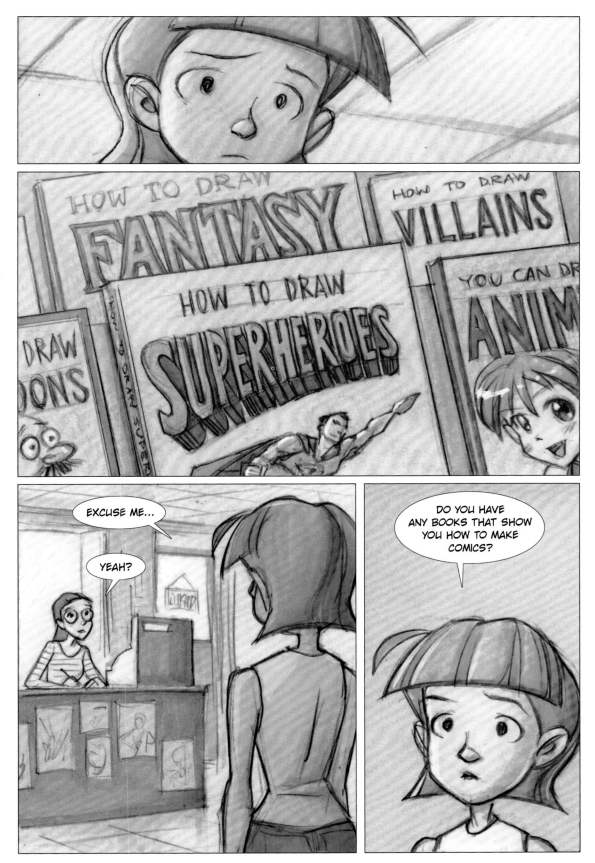

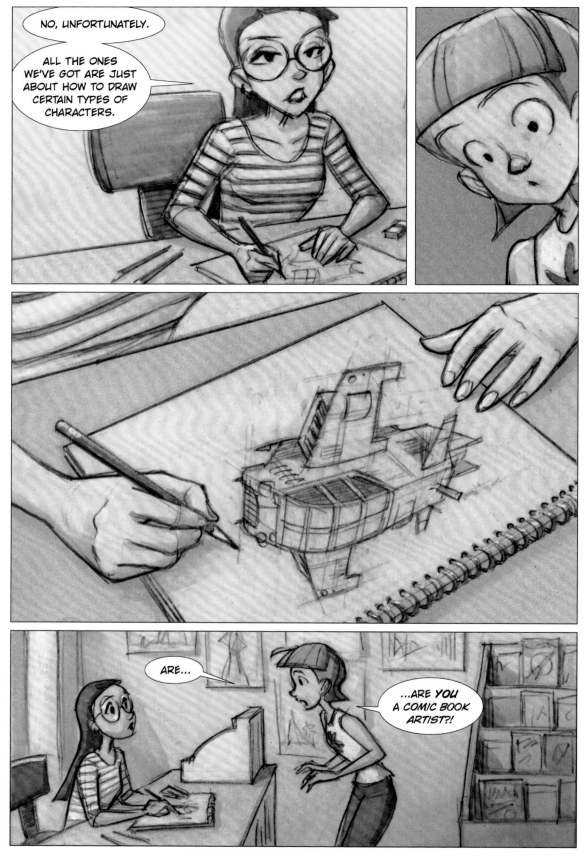

4

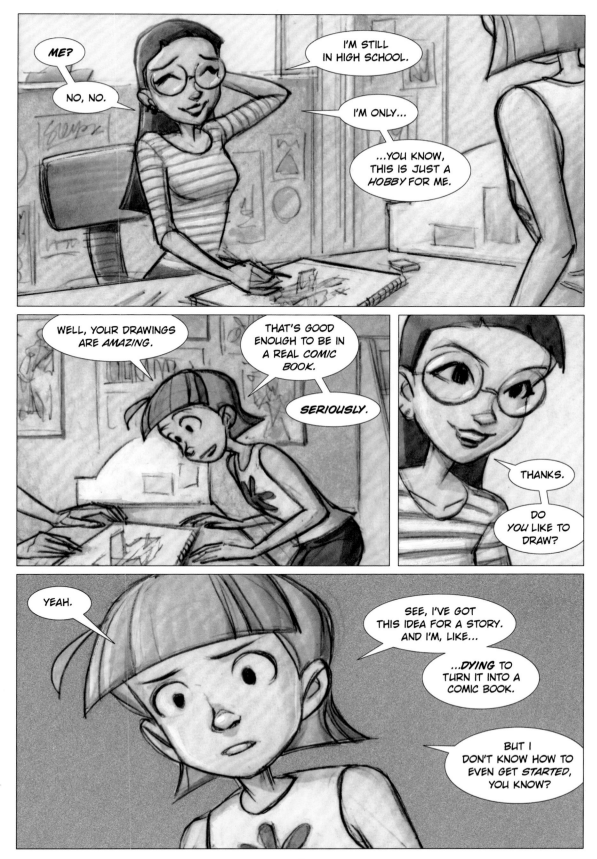

5

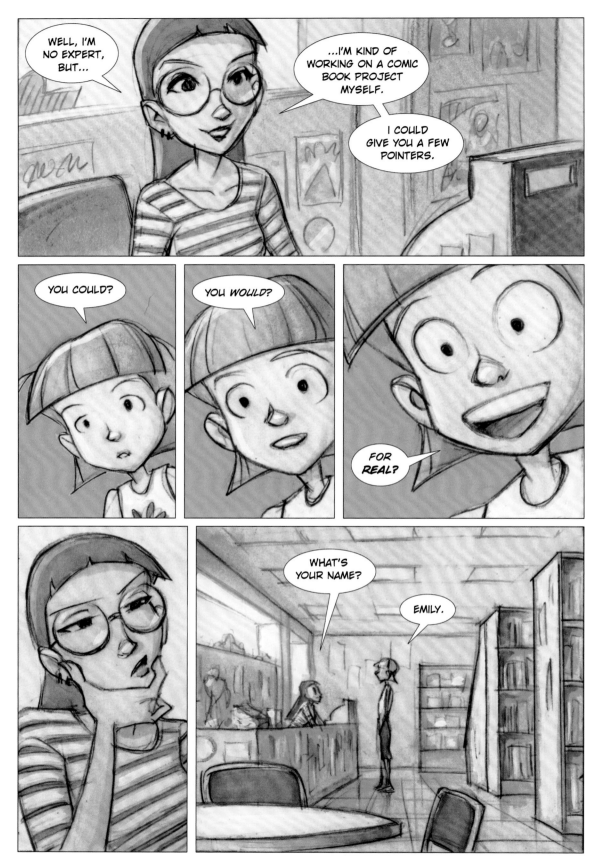

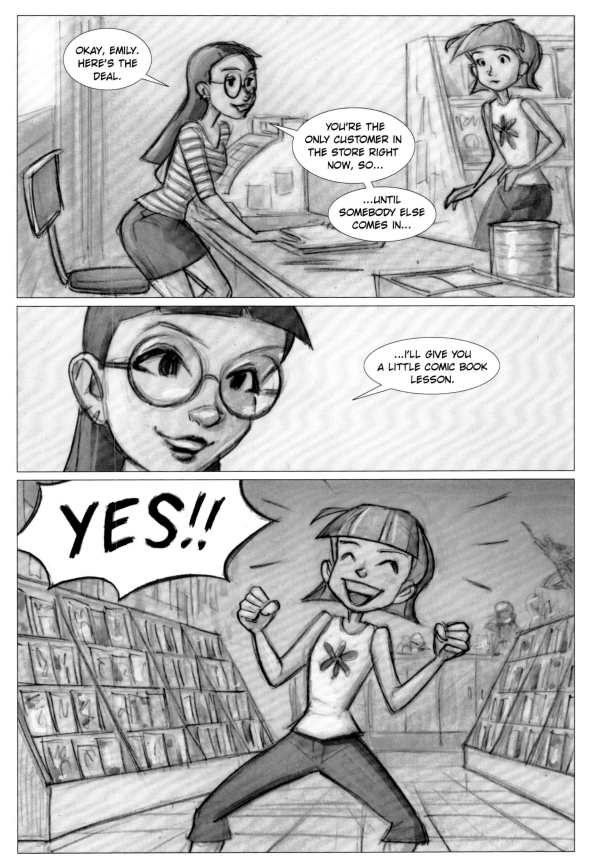

7

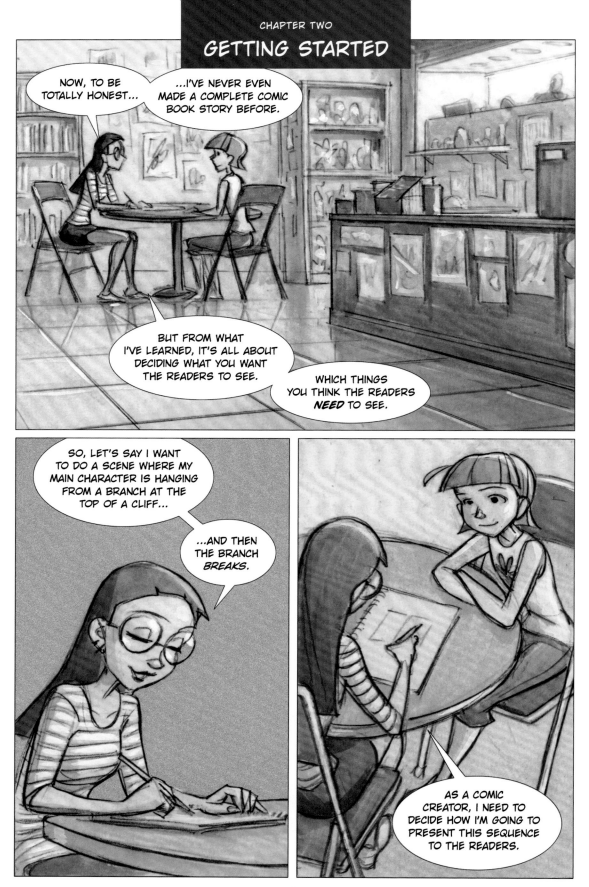

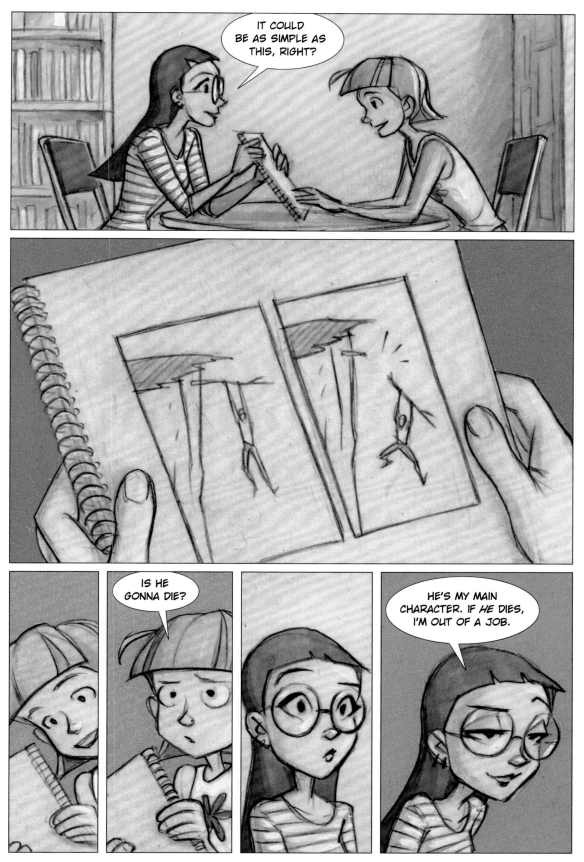

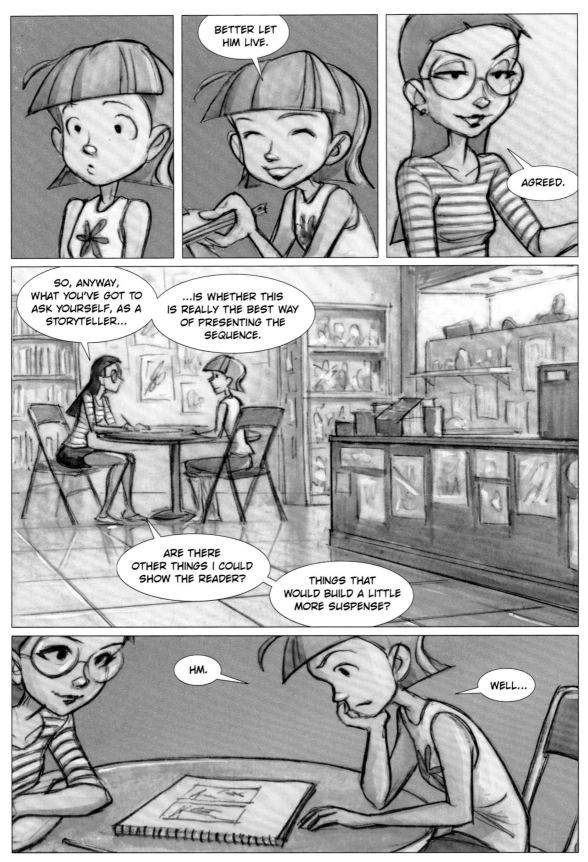

BETTER LET HIM LIVE.

AGREED.

SO, ANYWAY, WHAT YOU'VE GOT TO ASK YOURSELF, AS A STORYTELLER...

...IS WHETHER THIS IS REALLY THE BEST WAY OF PRESENTING THE SEQUENCE.

ARE THERE OTHER THINGS I COULD SHOW THE READER?

THINGS THAT WOULD BUILD A LITTLE MORE SUSPENSE?

HM.

WELL...

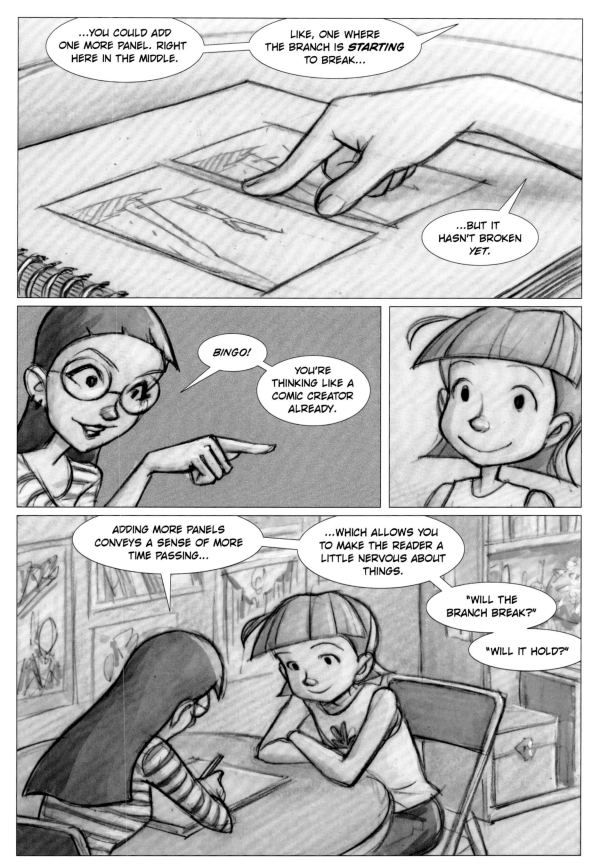

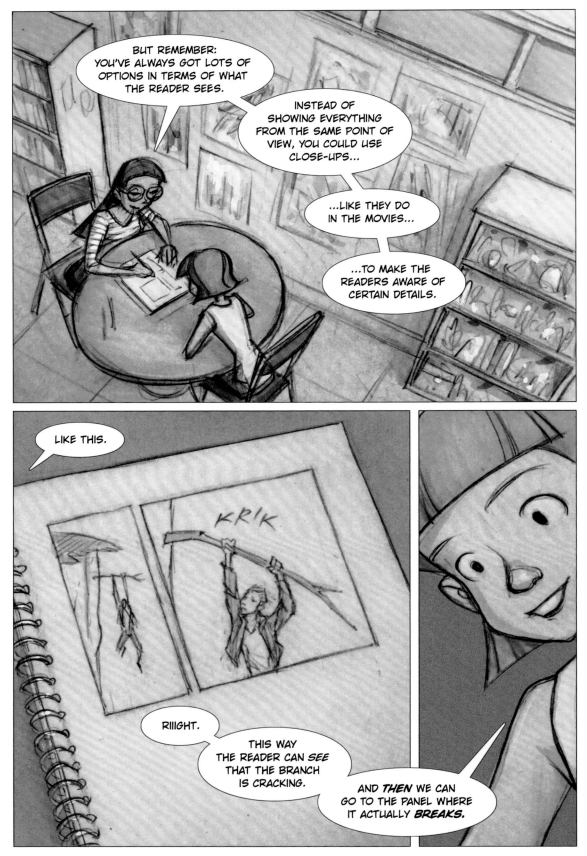

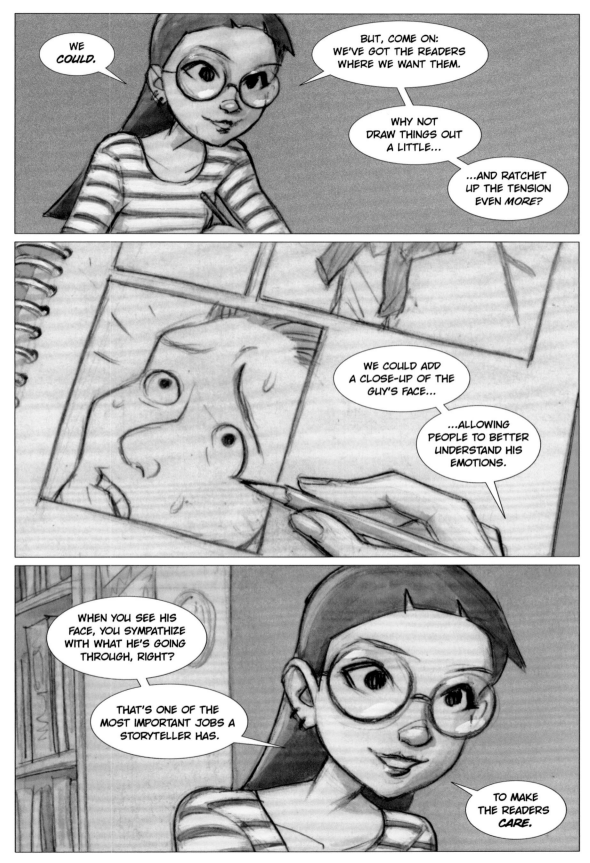

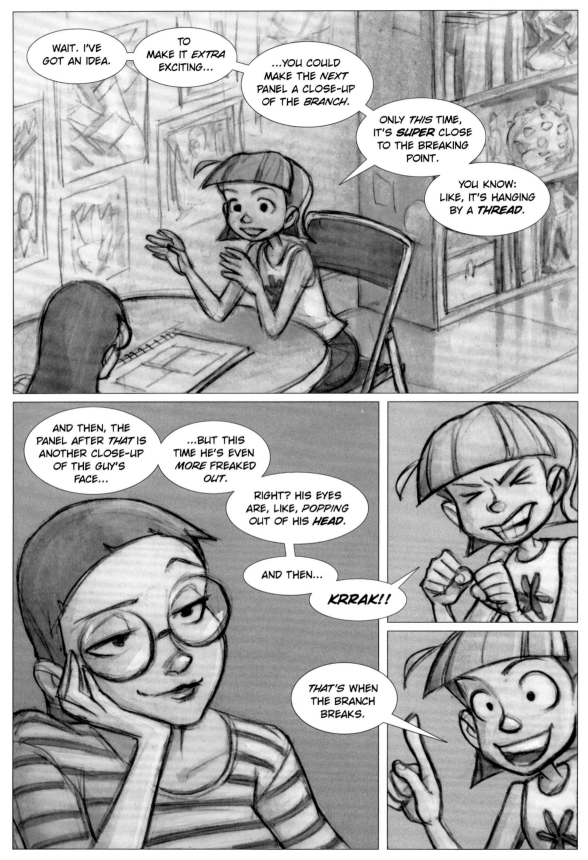

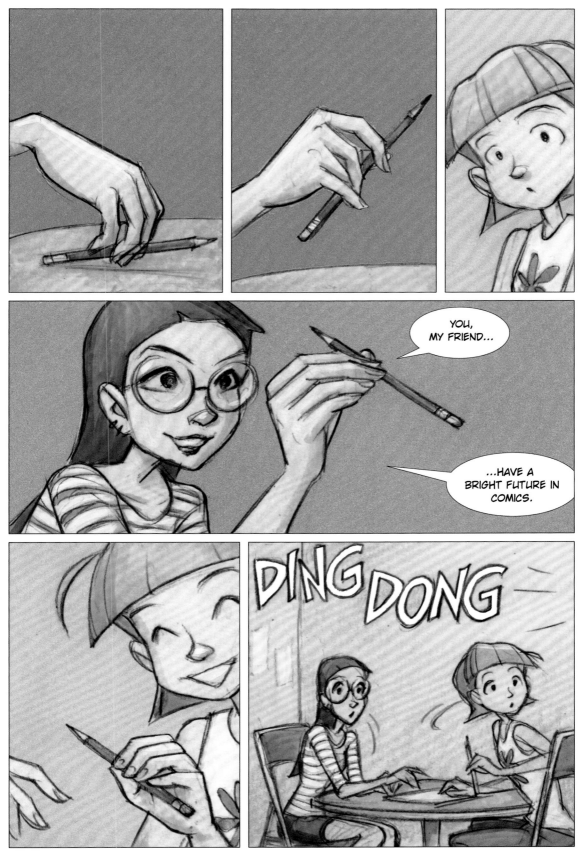

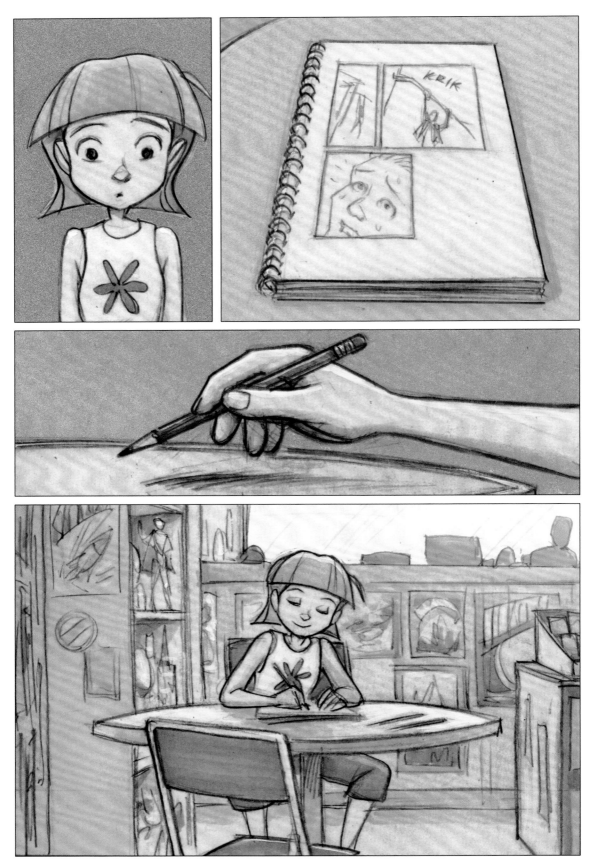

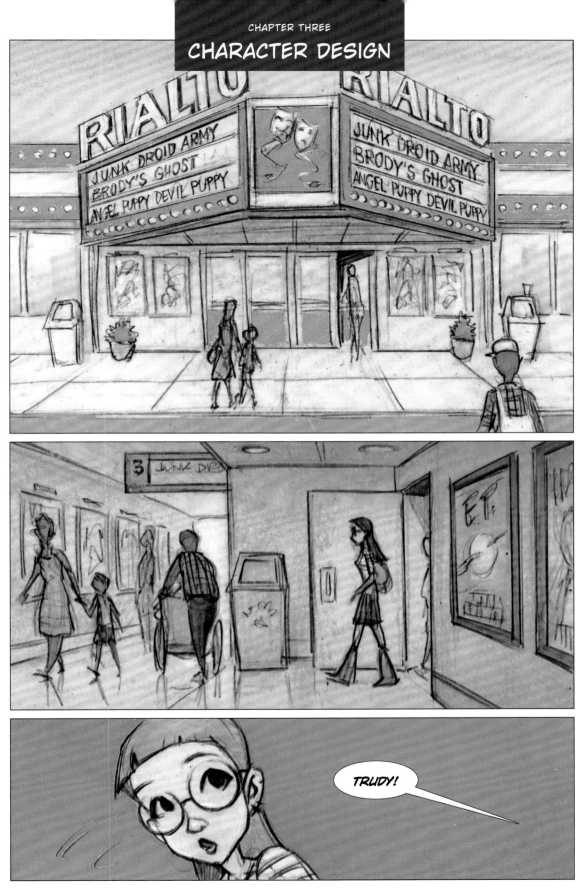

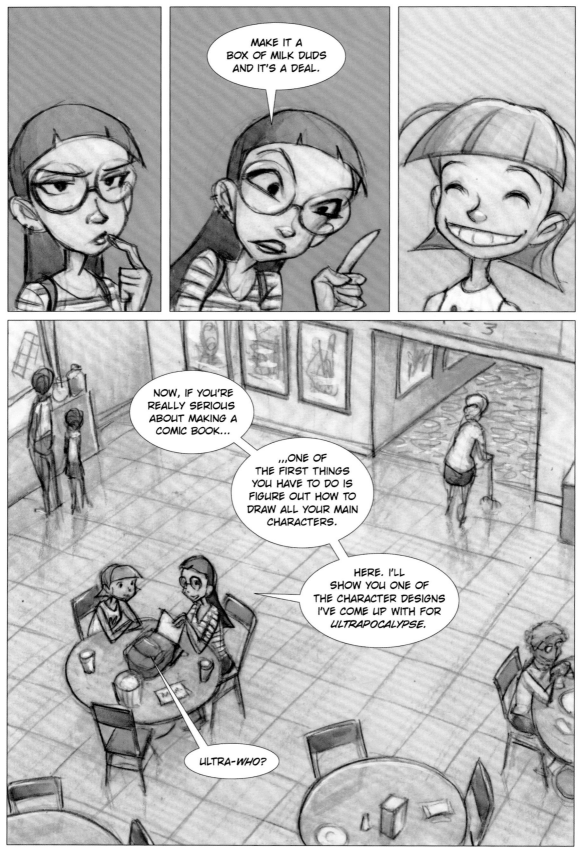

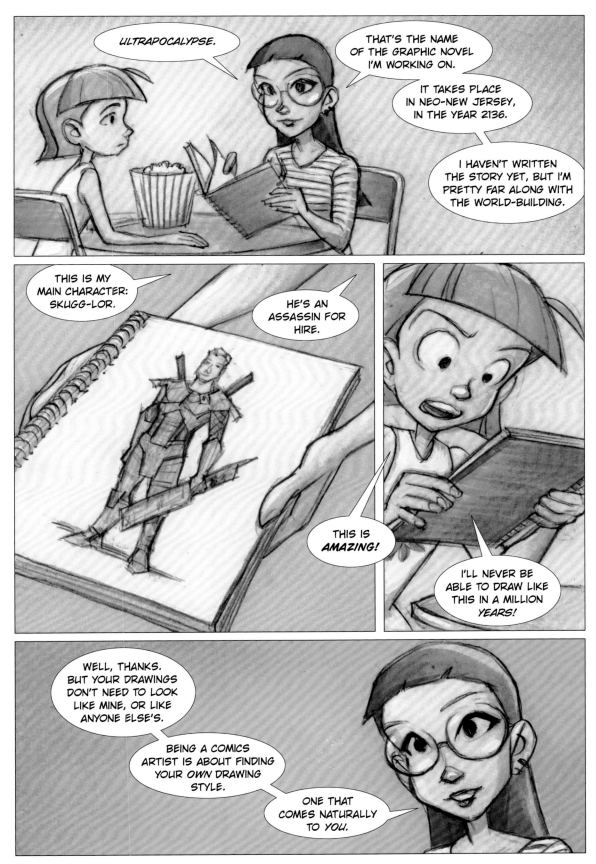

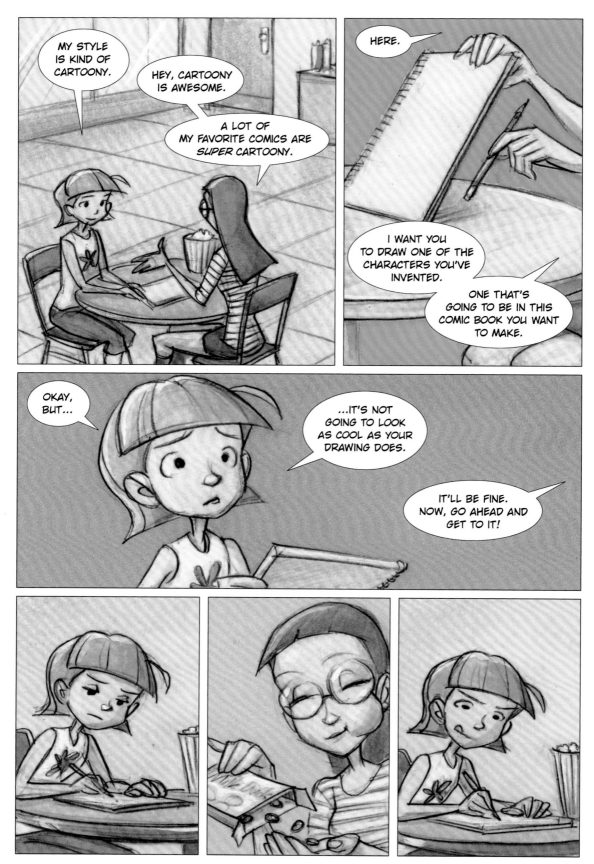

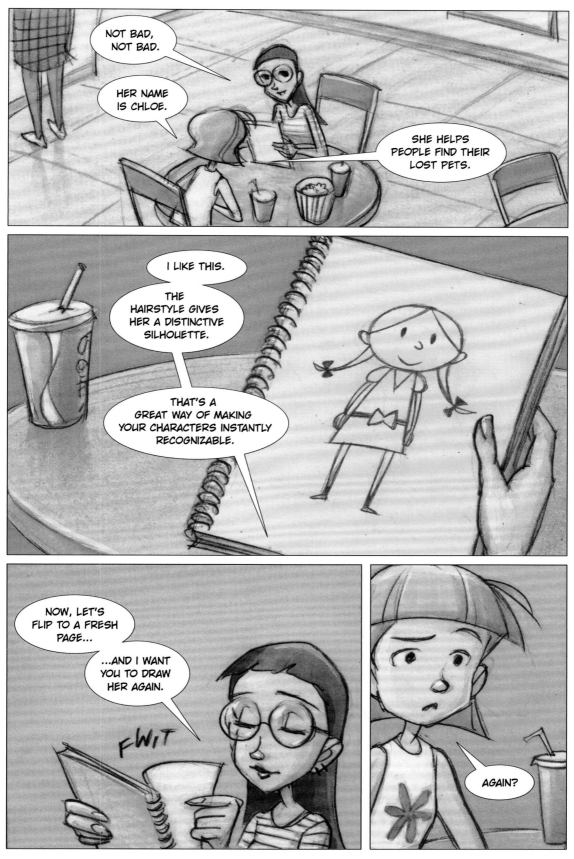

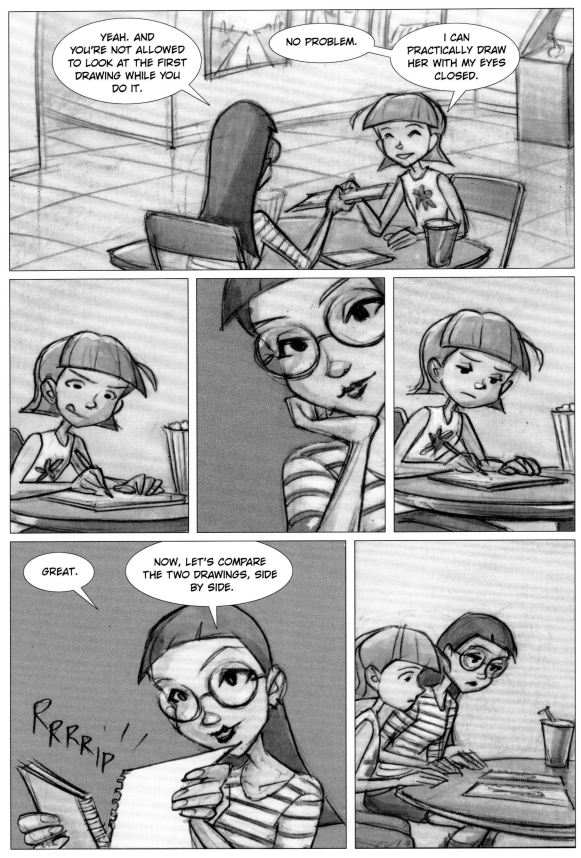

26

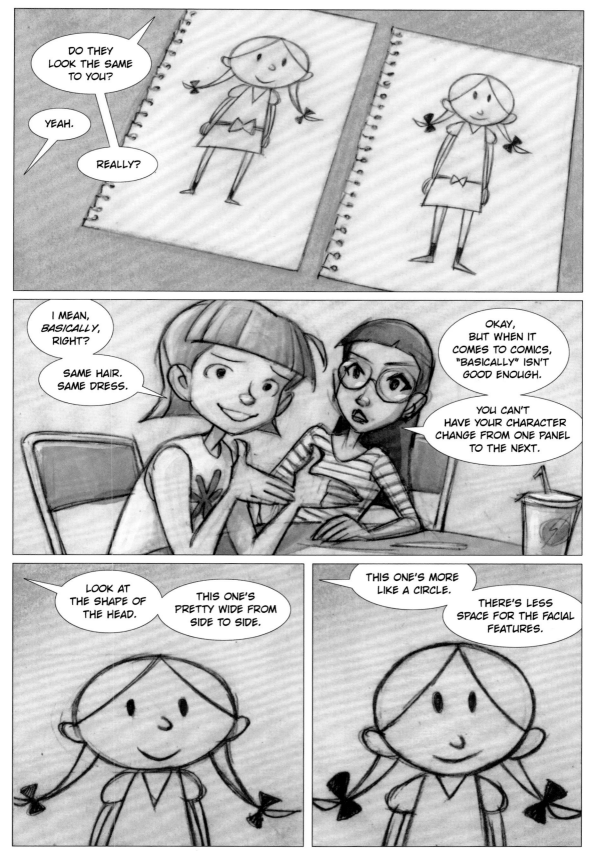

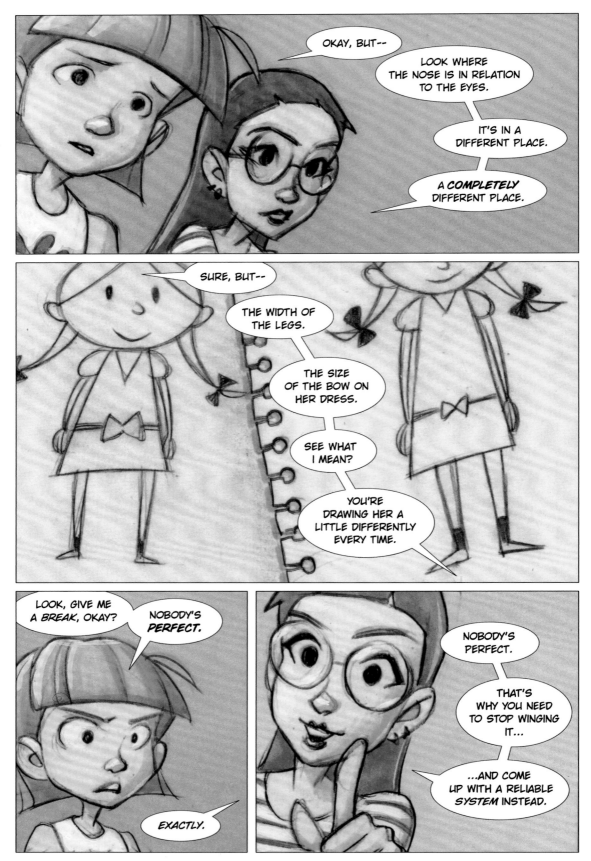

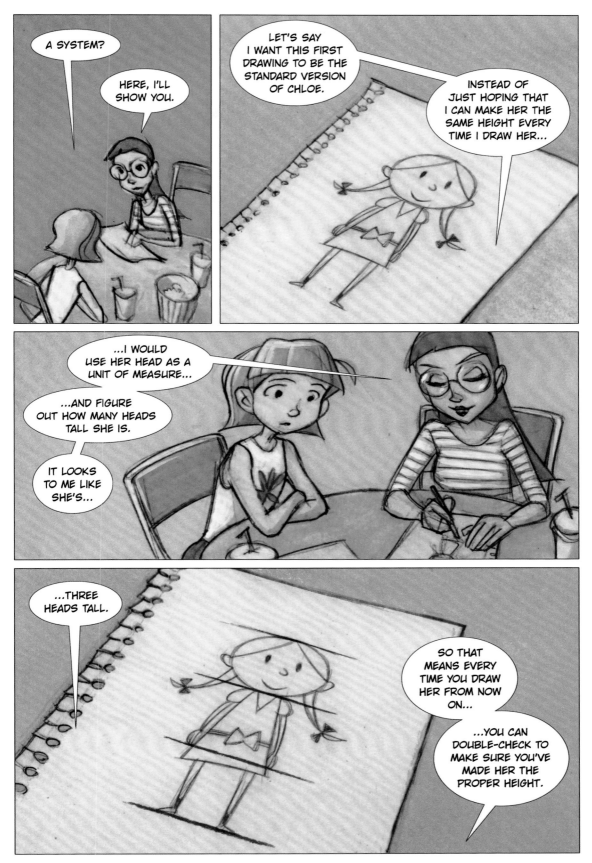

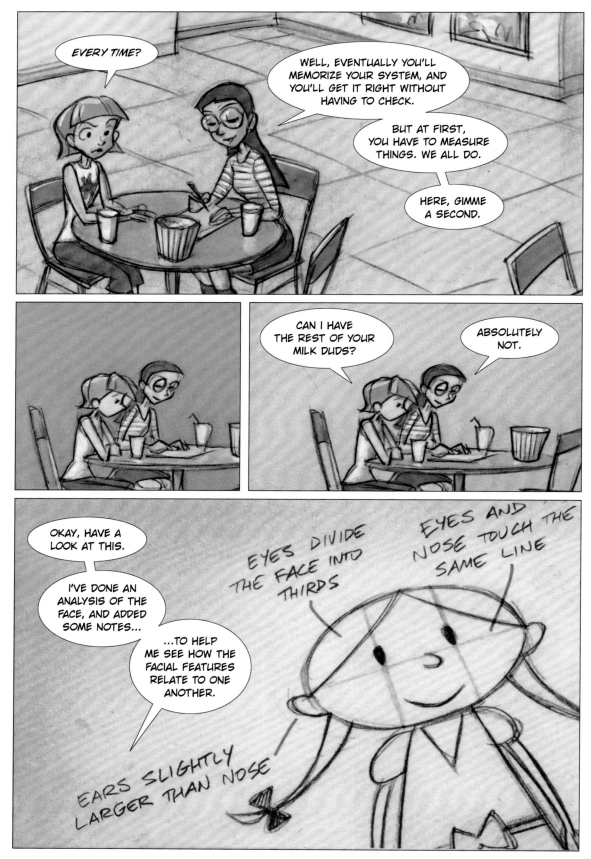

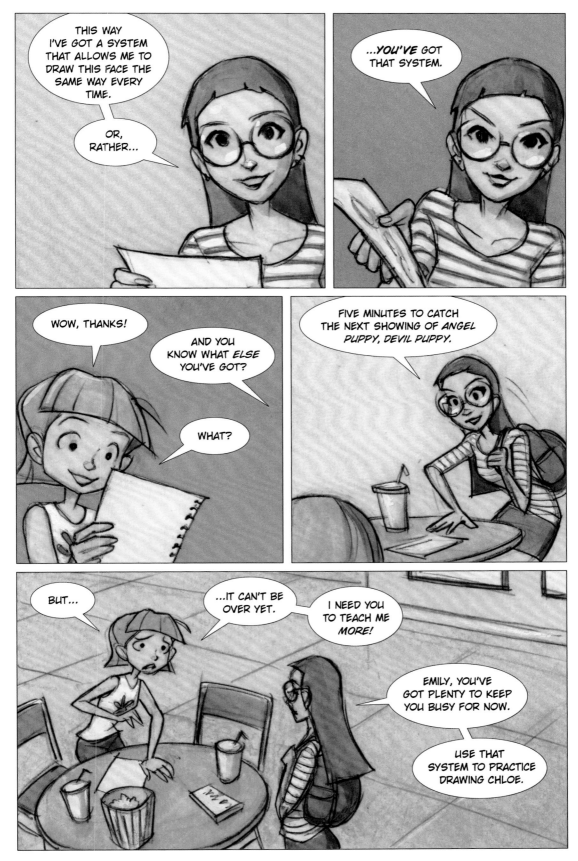

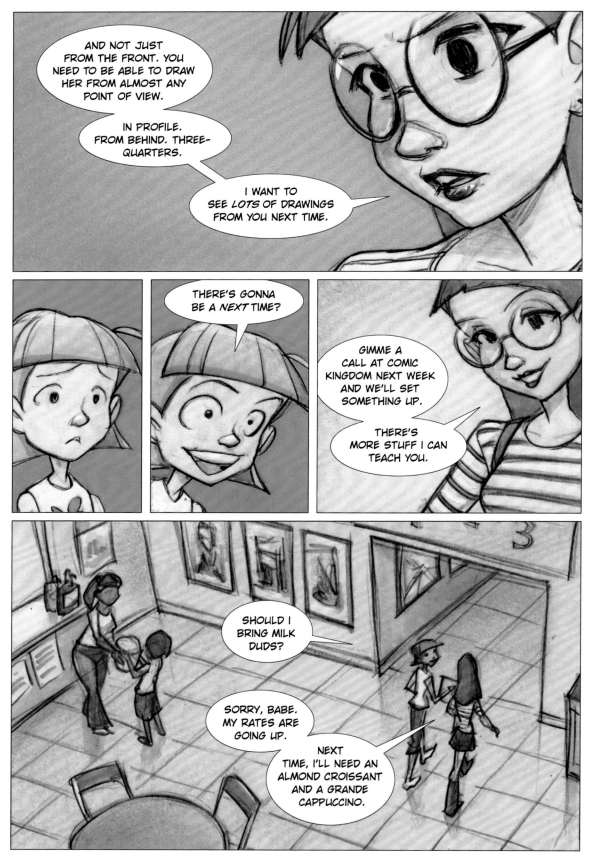

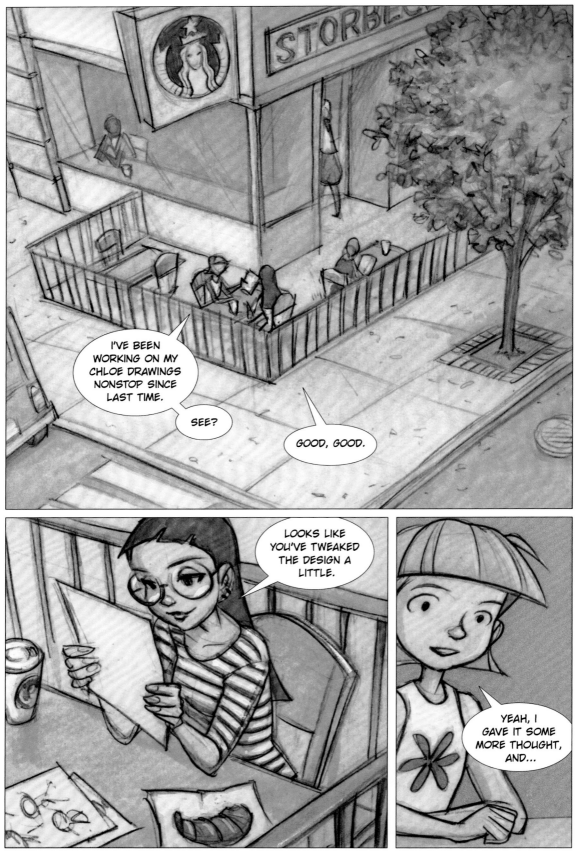

34

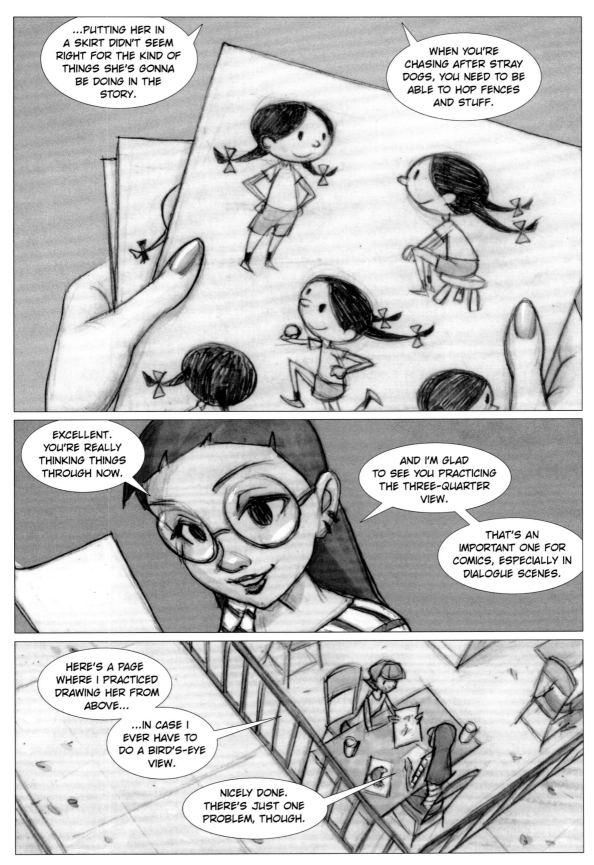

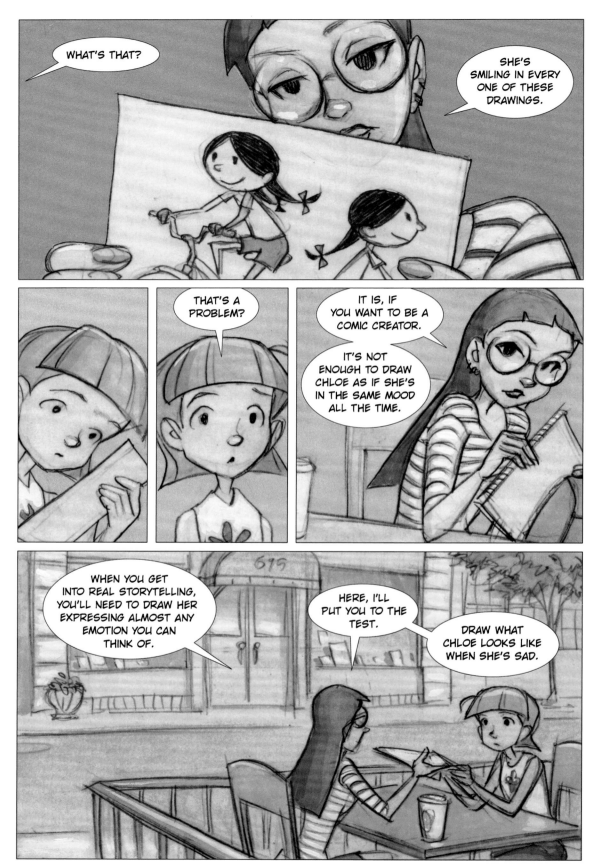

36

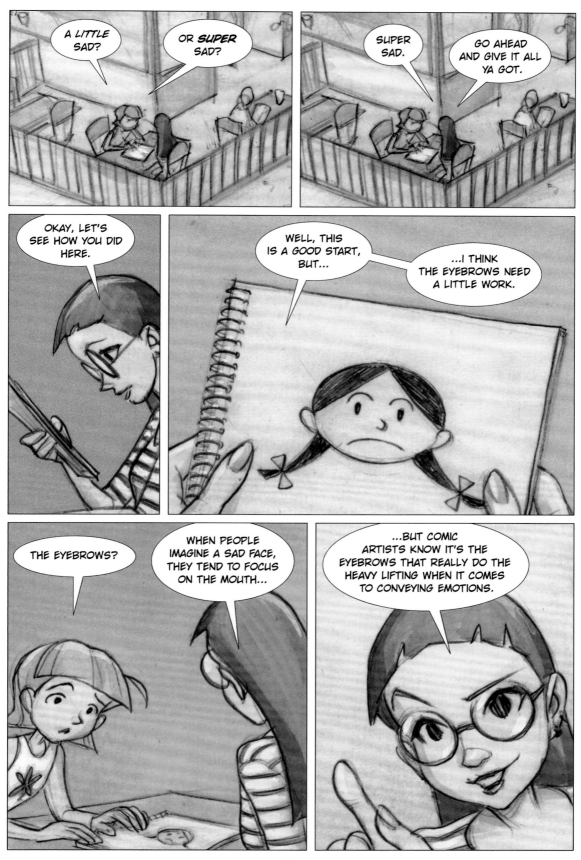

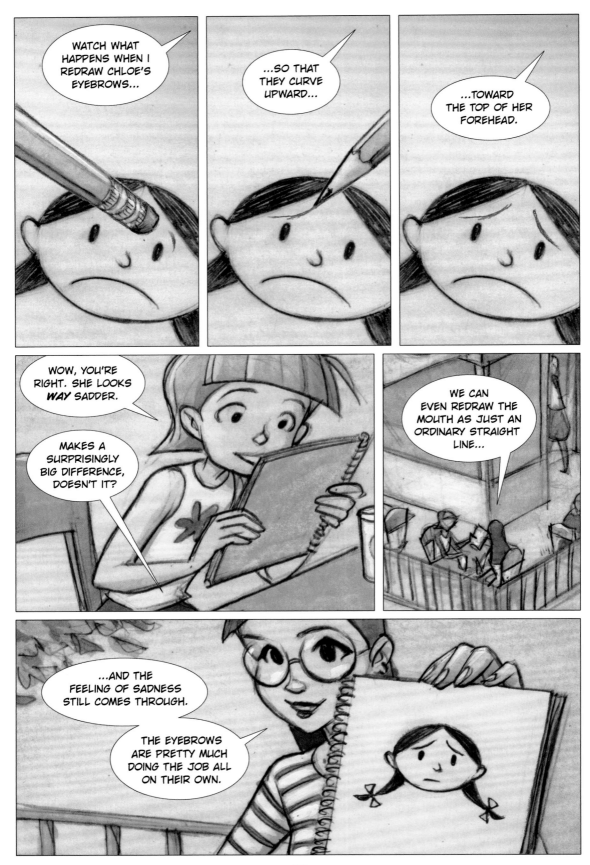

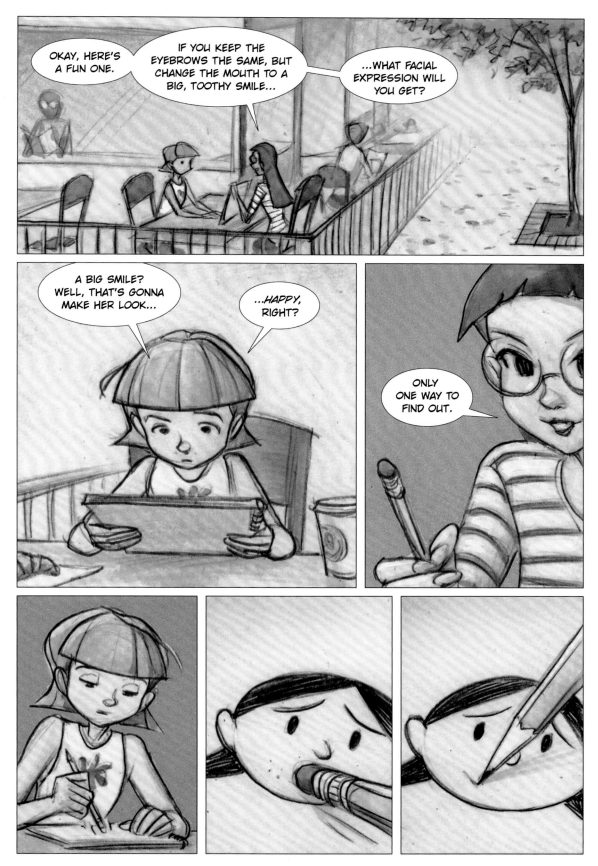

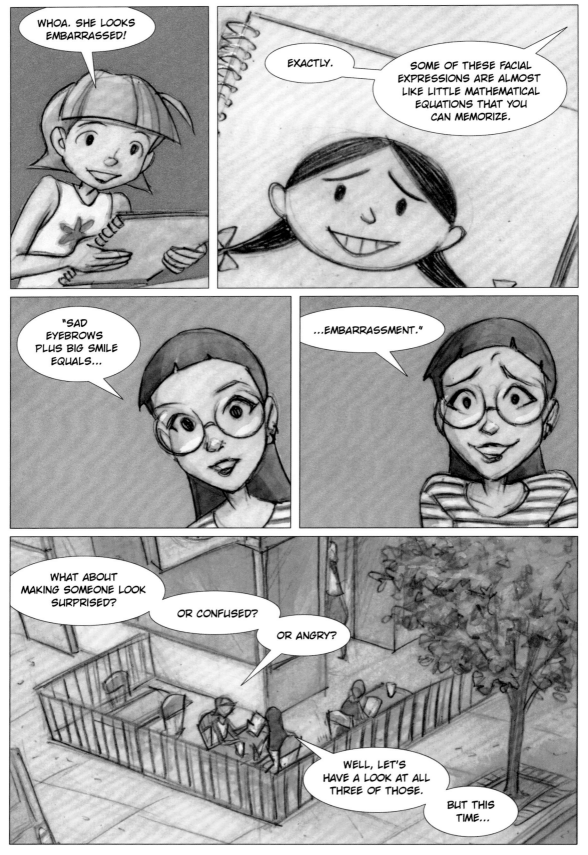

40

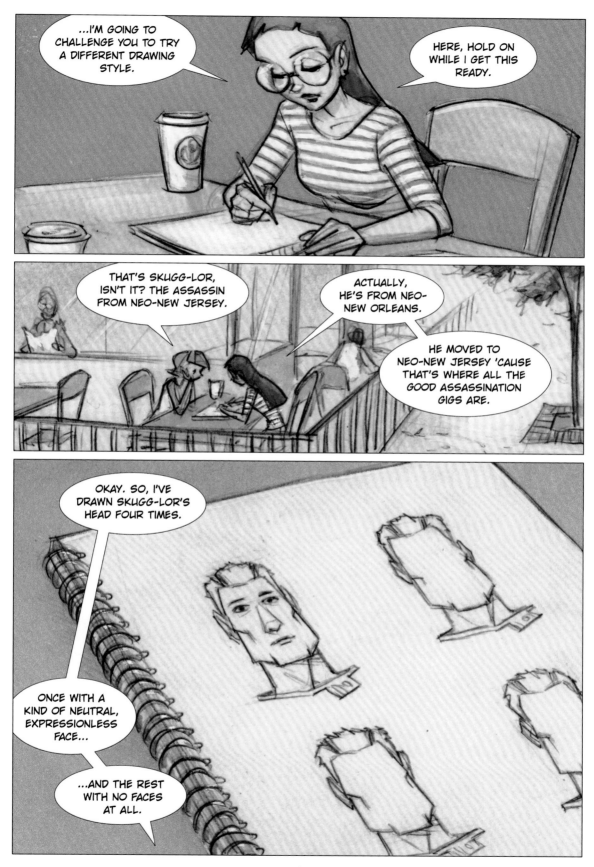

41

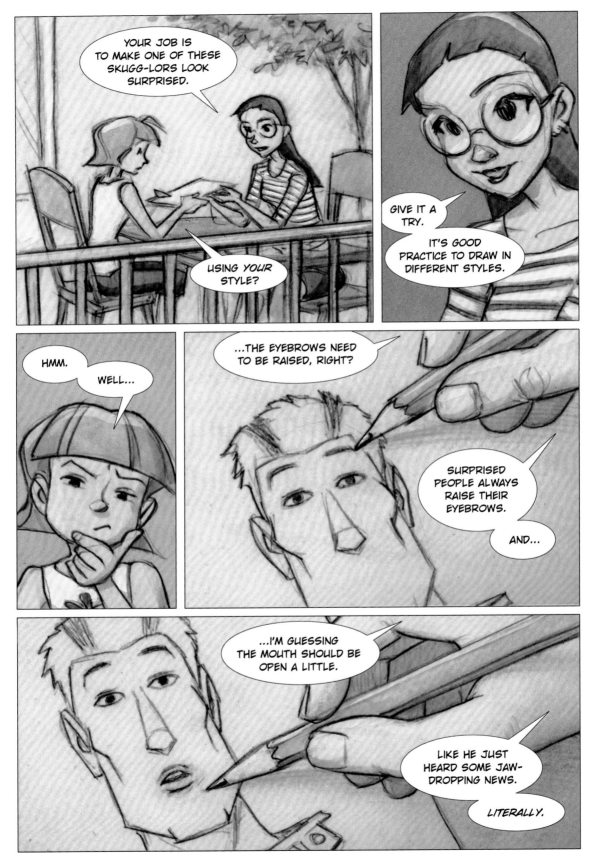

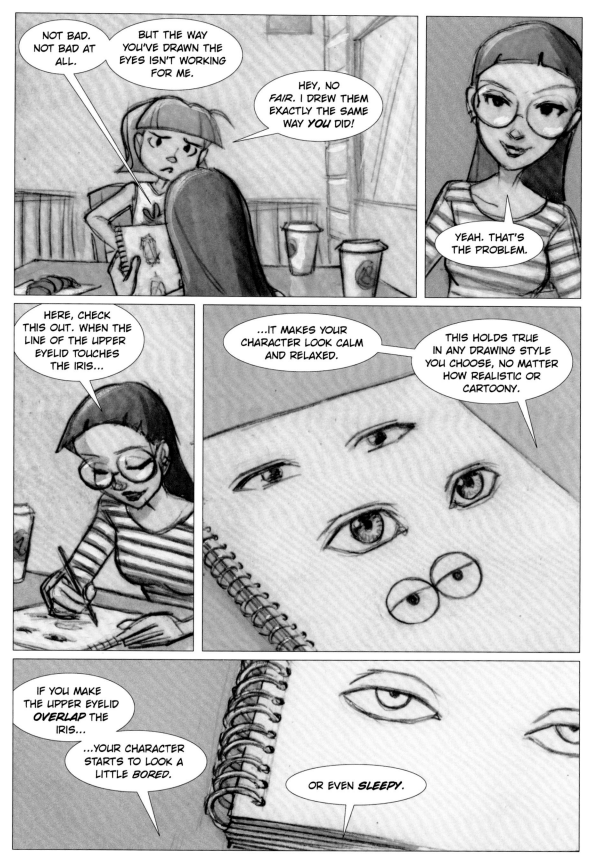

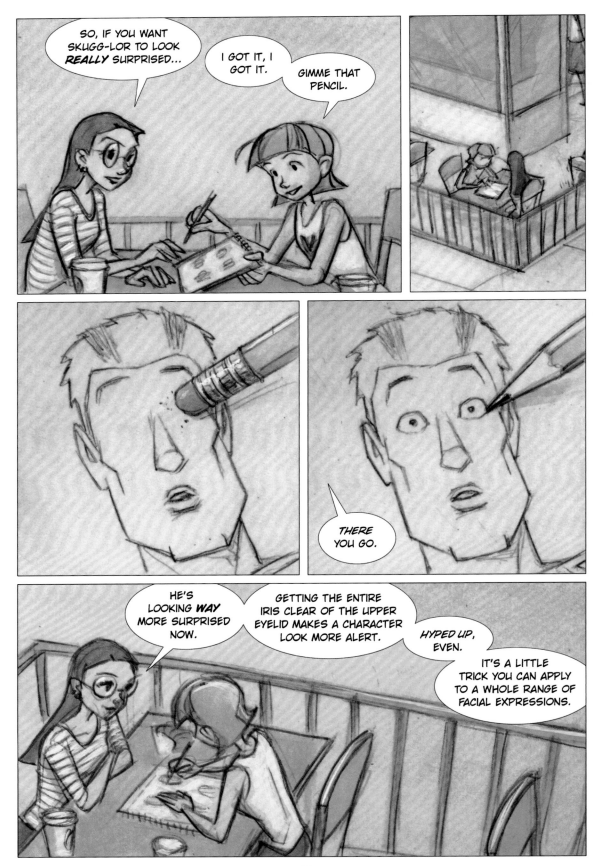

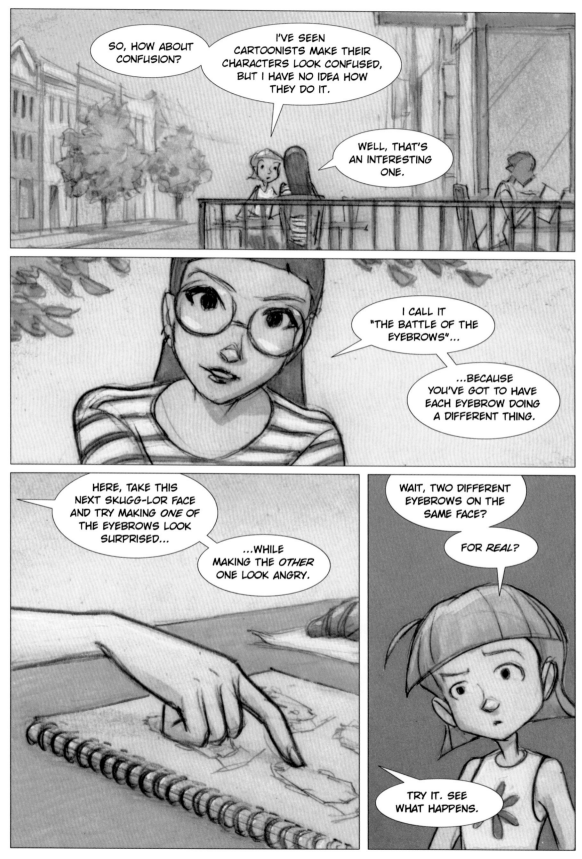

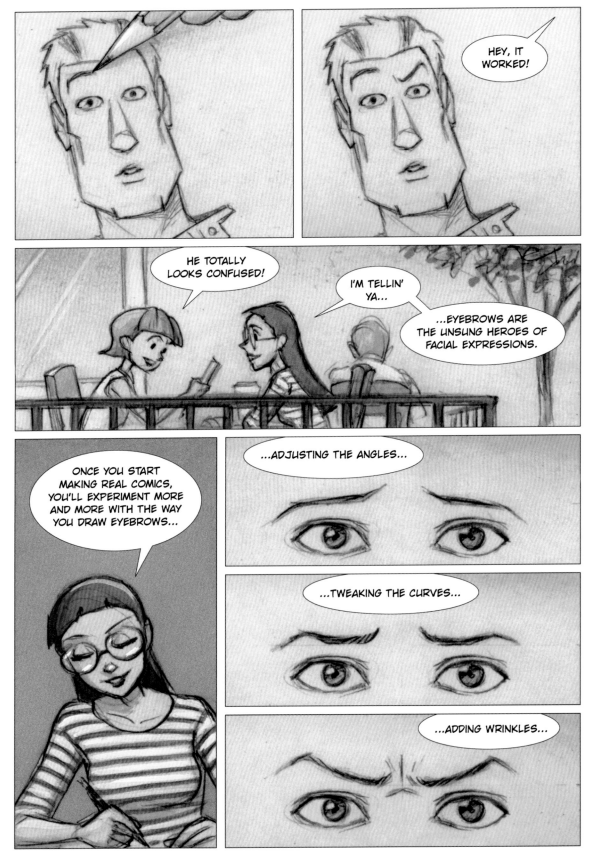

49

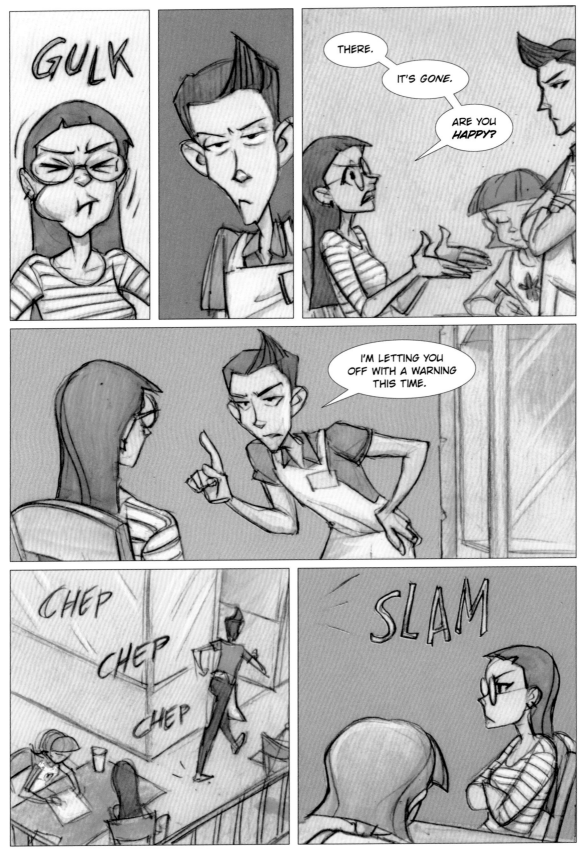

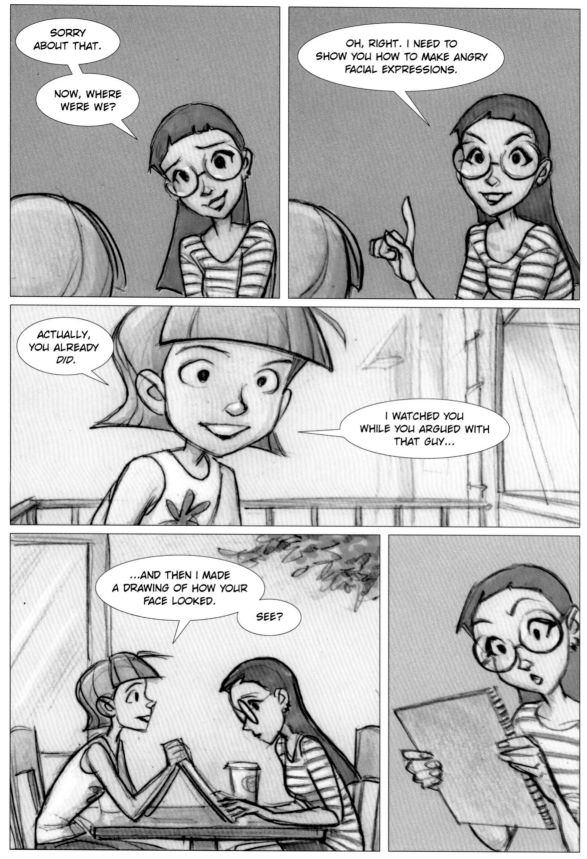

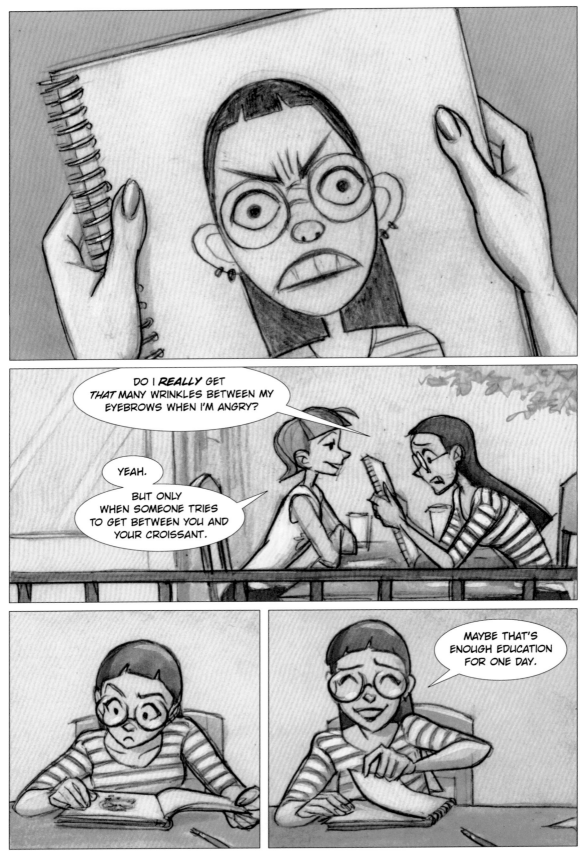

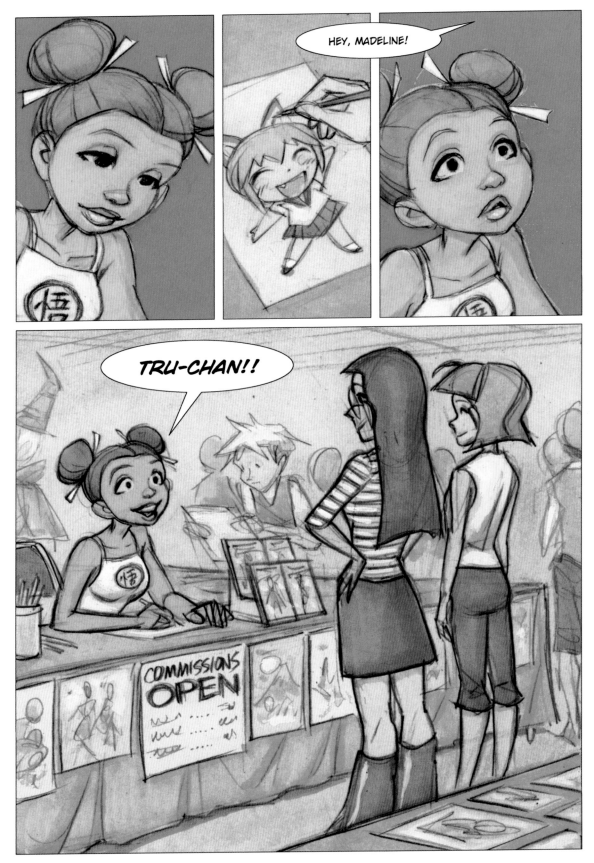

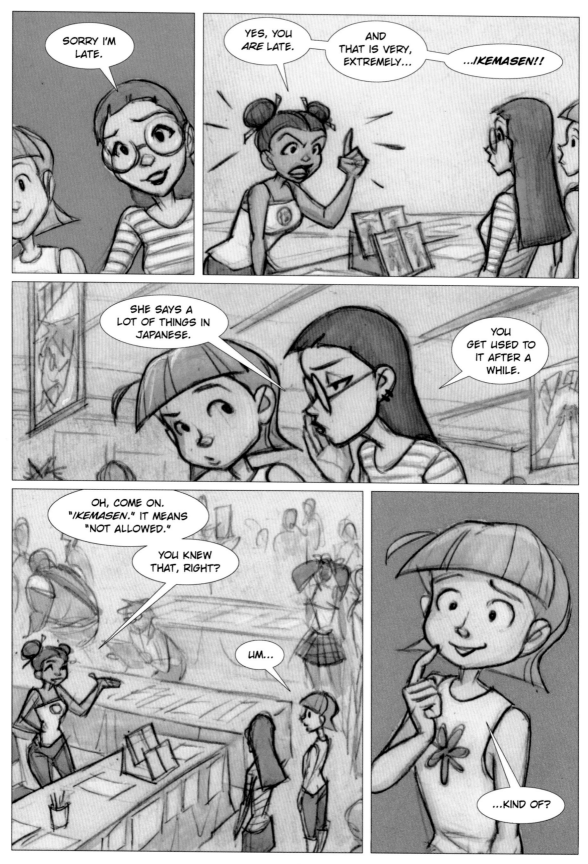

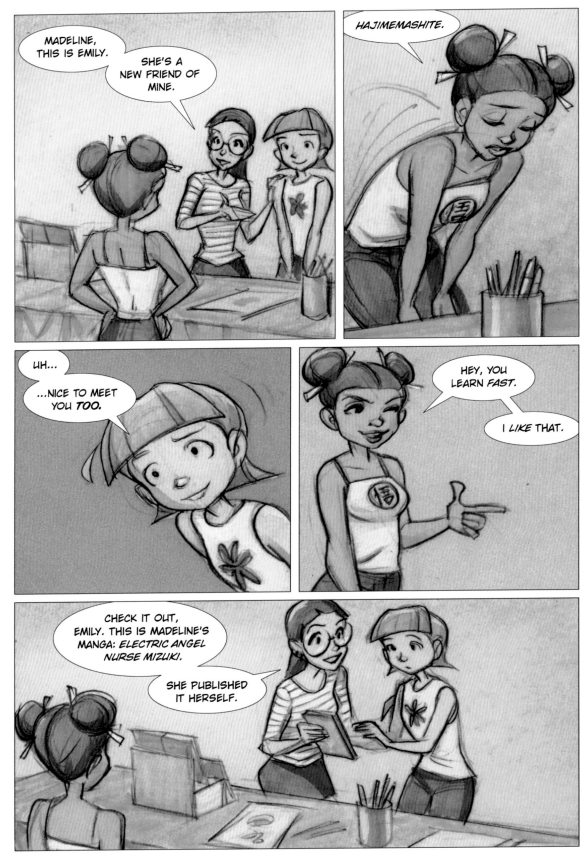

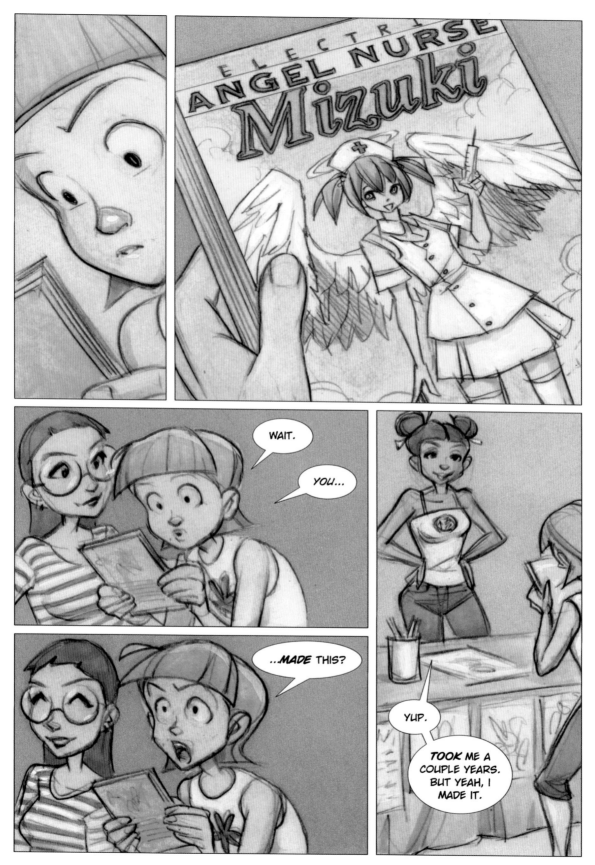

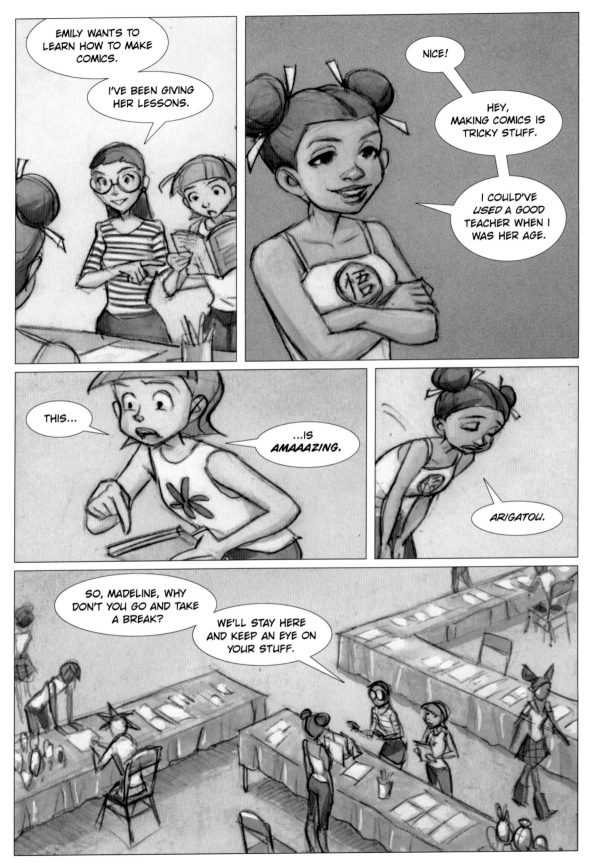

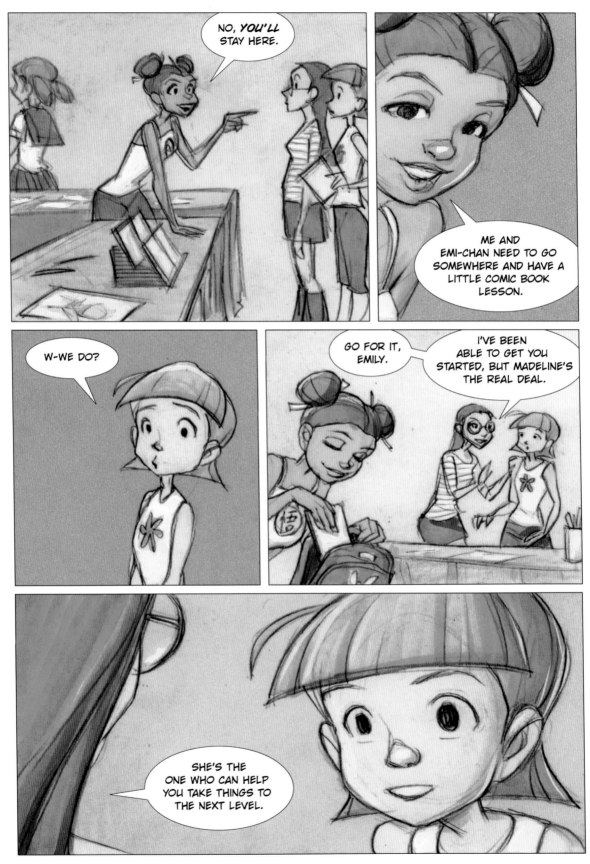

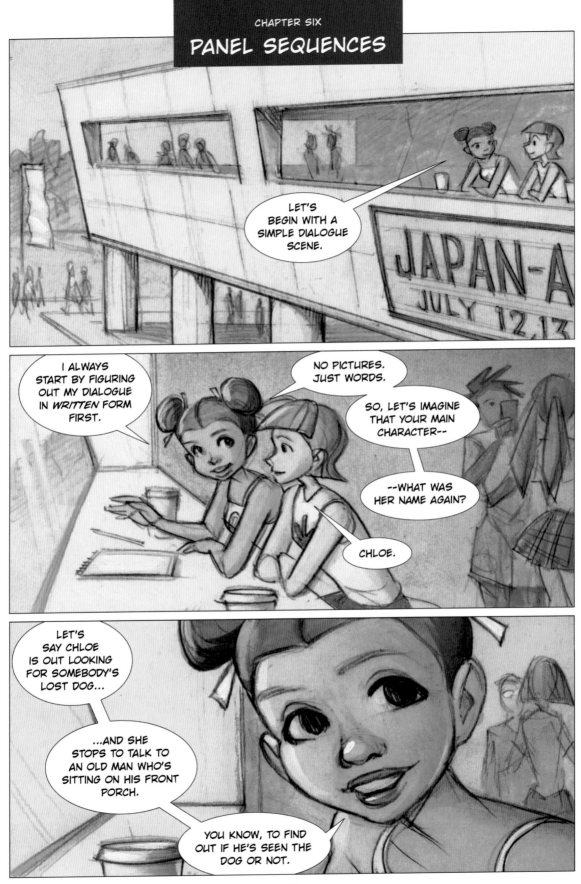

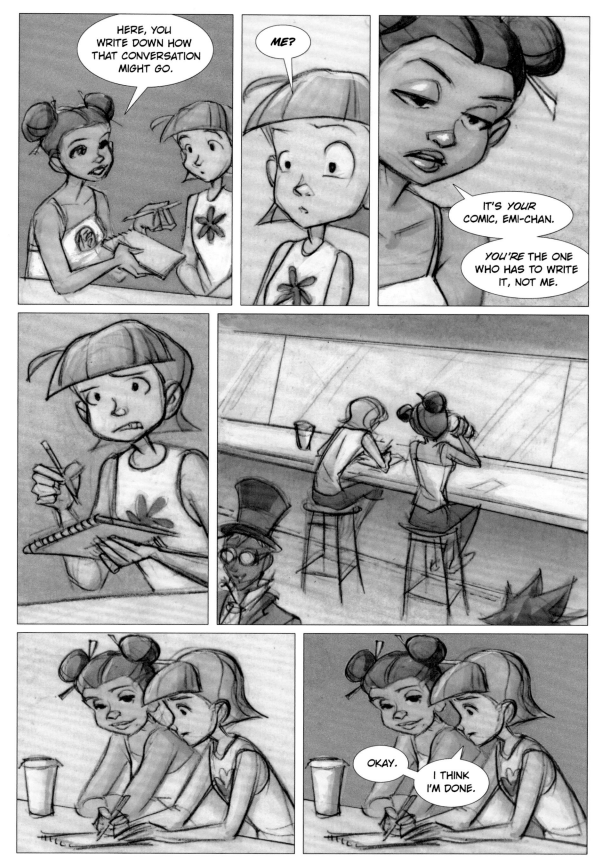

66

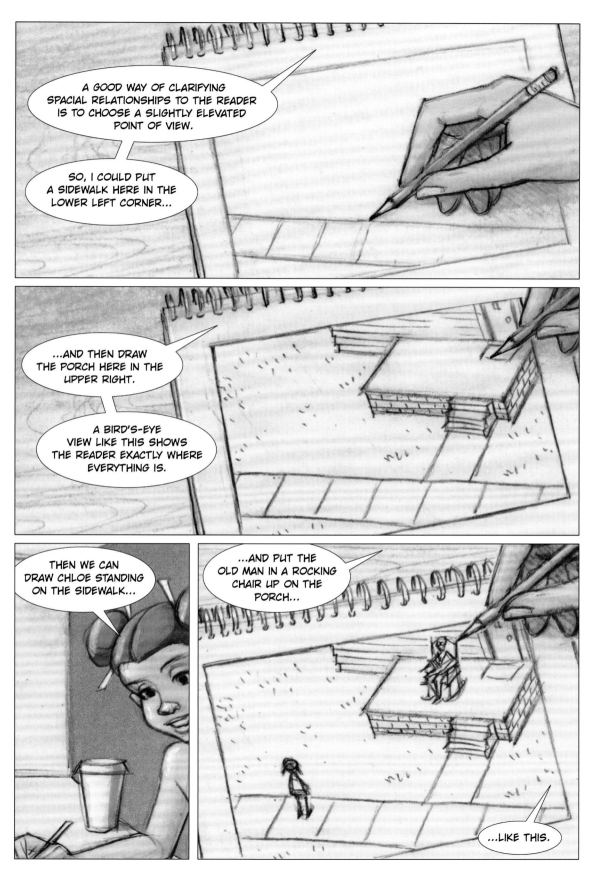

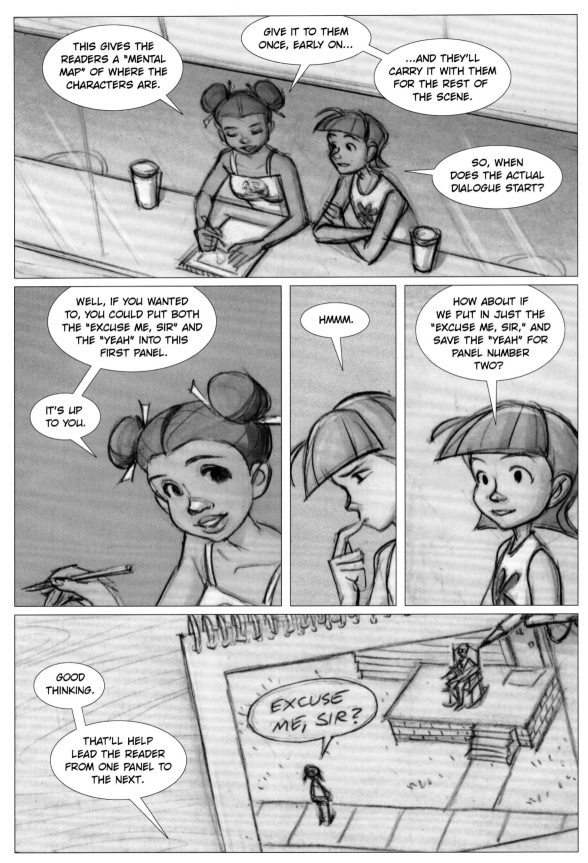

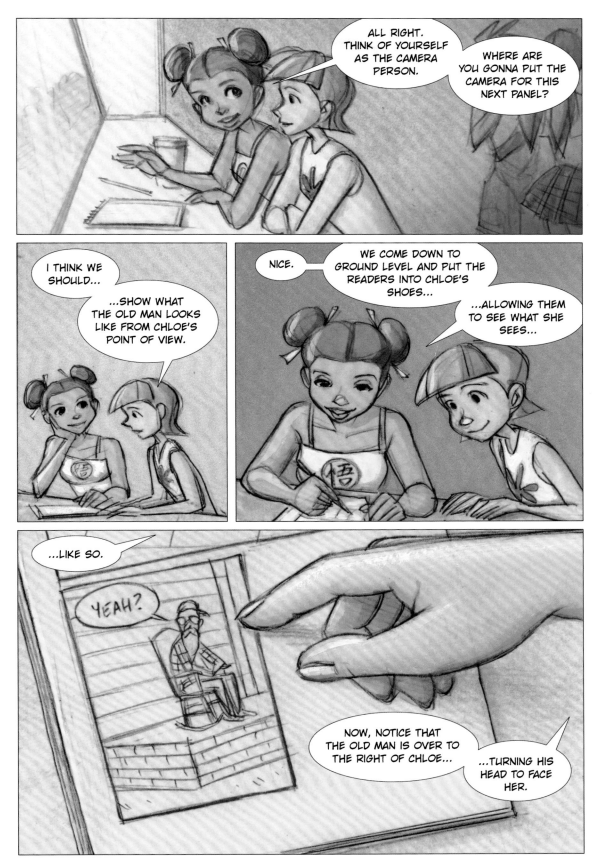

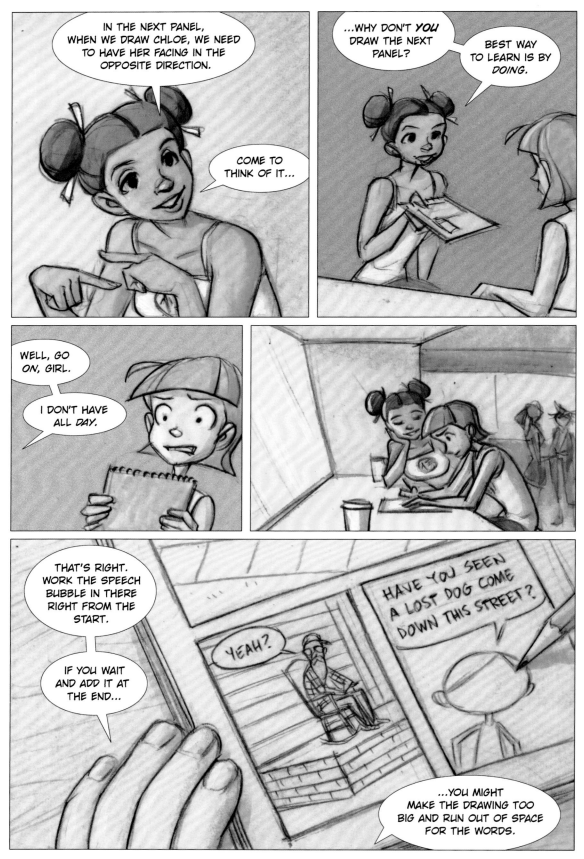

70

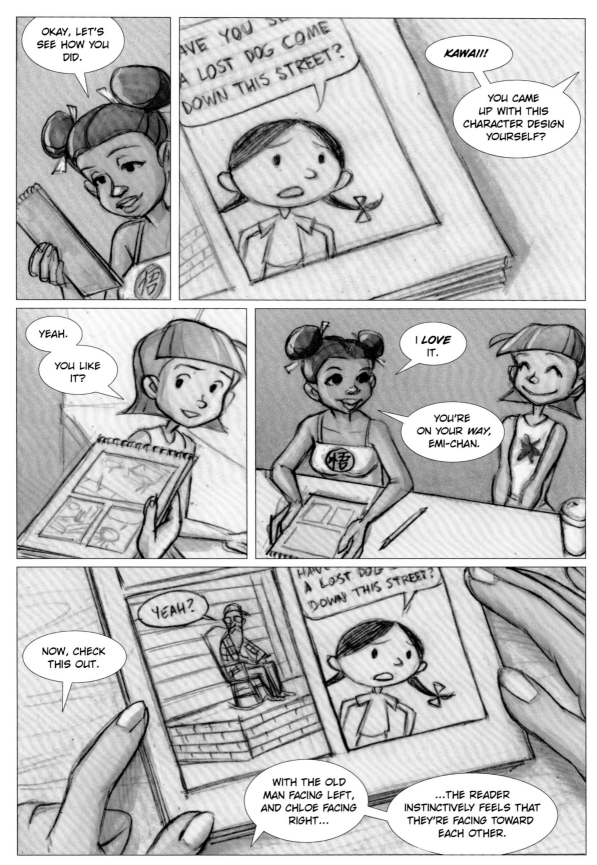

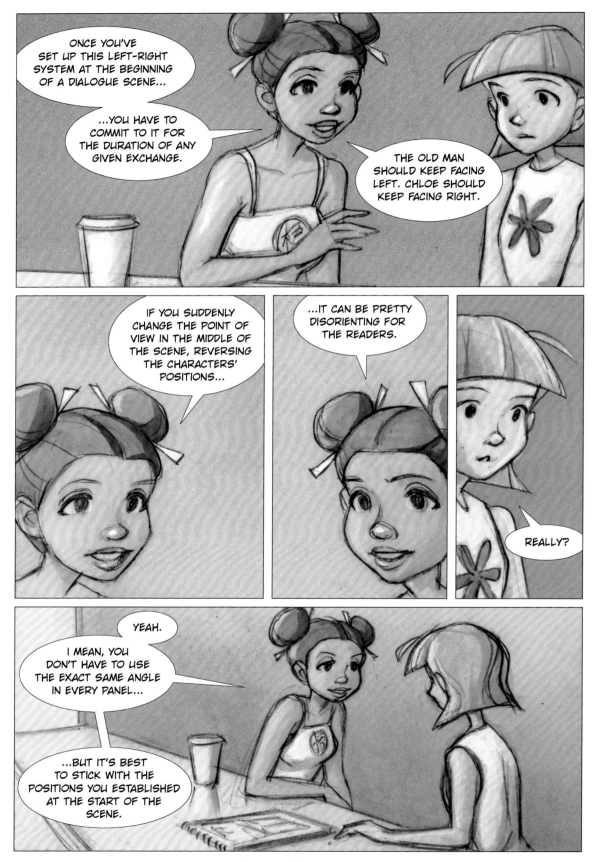

73

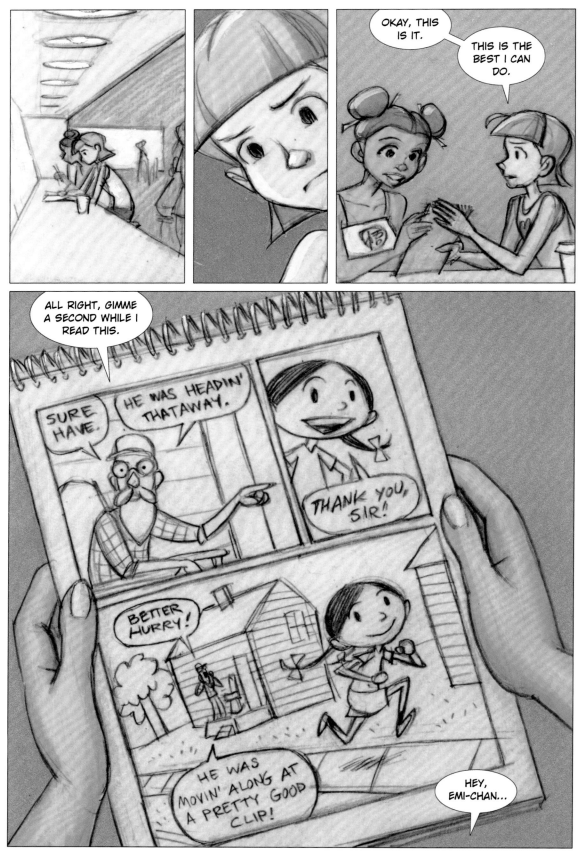

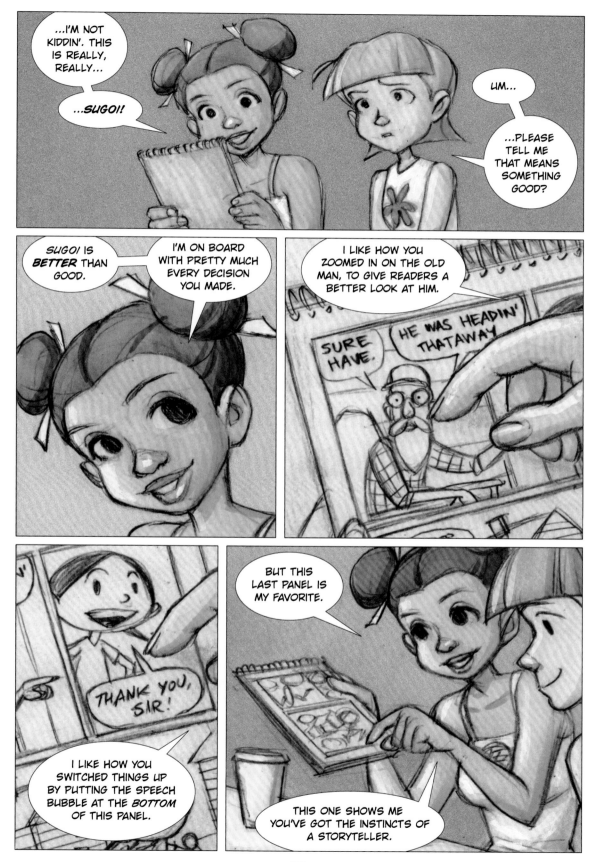

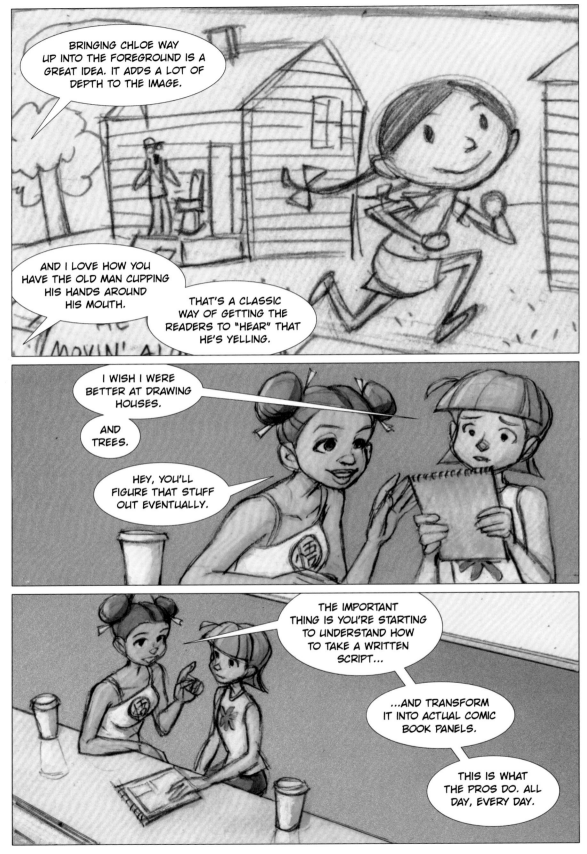

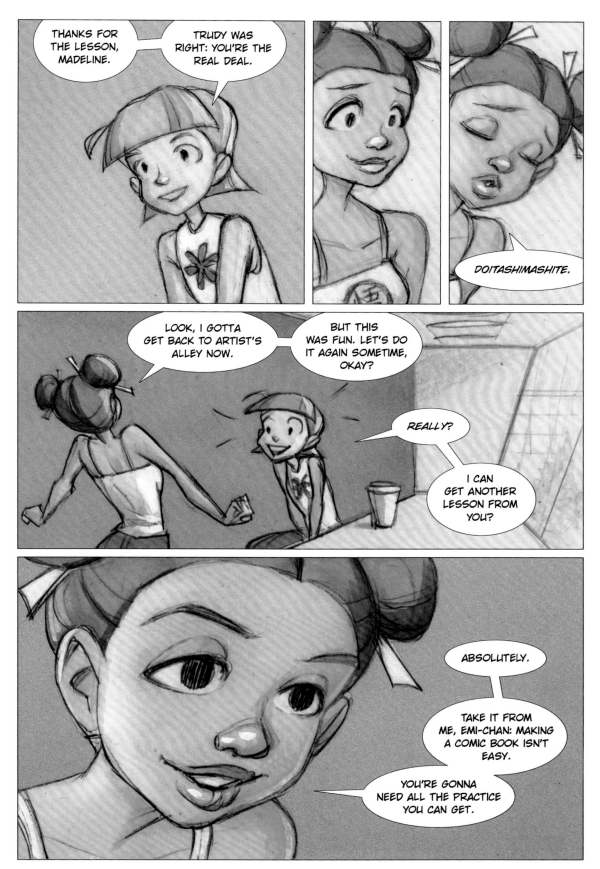

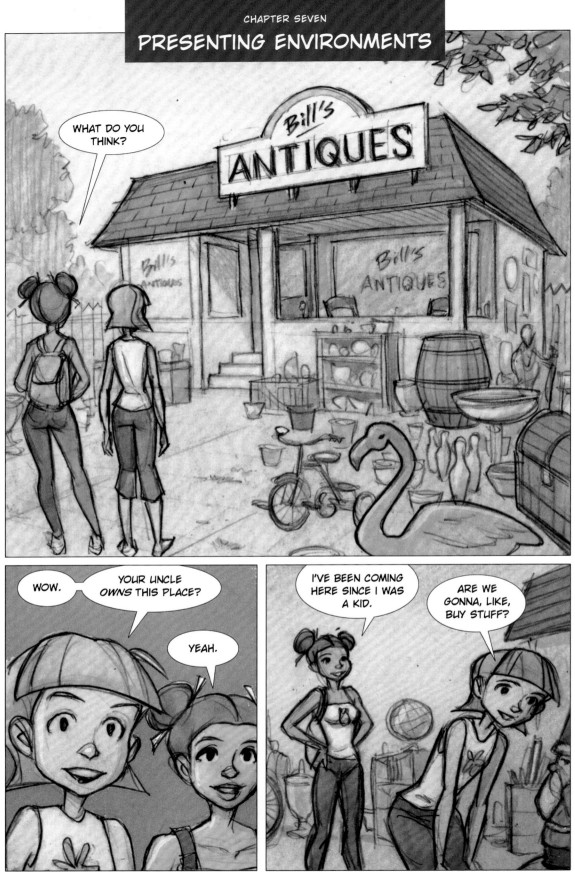

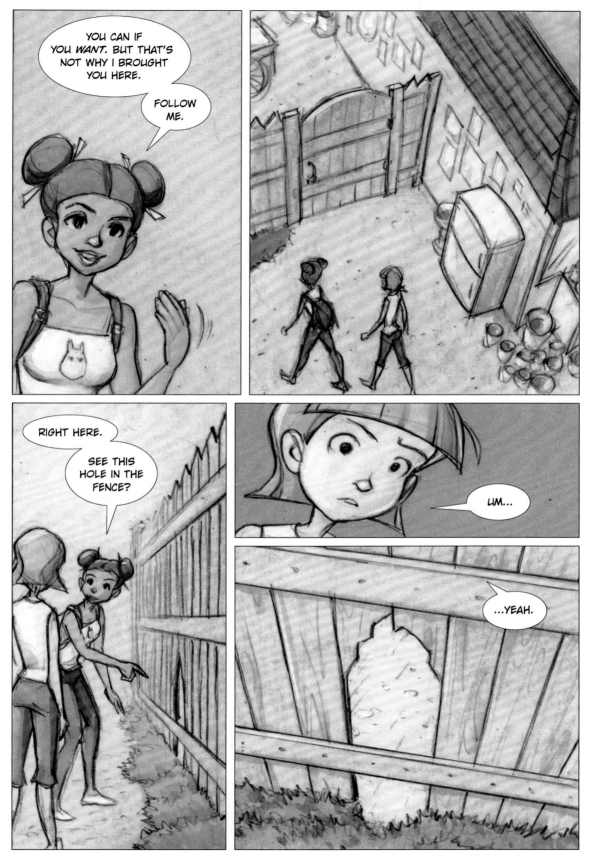

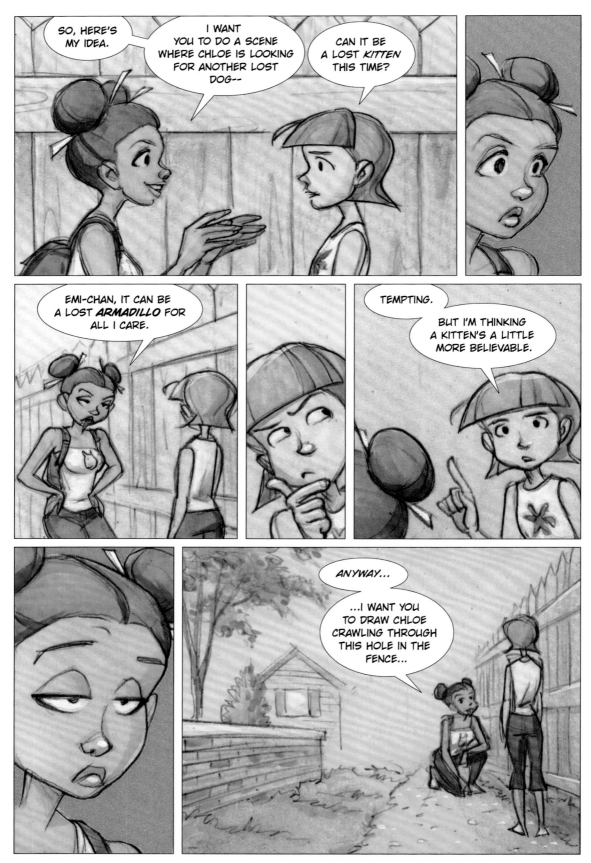

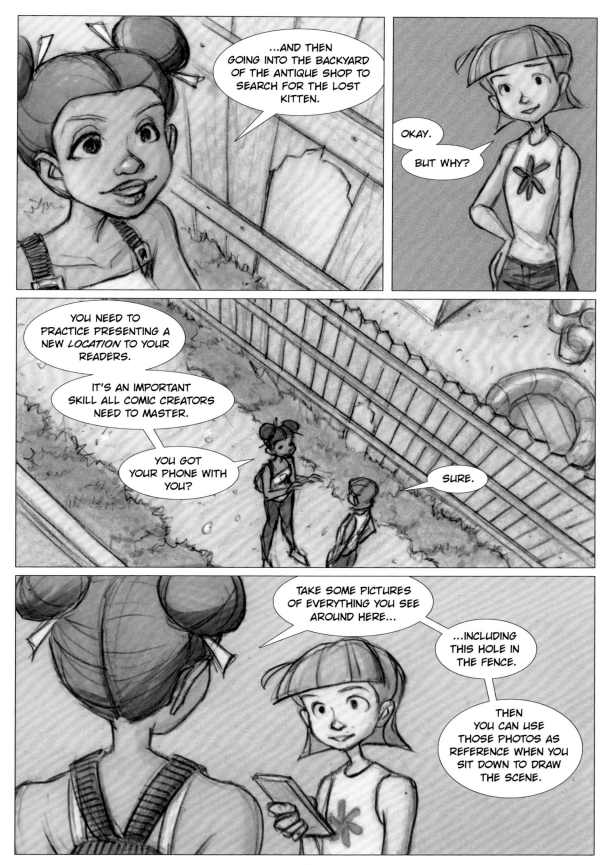

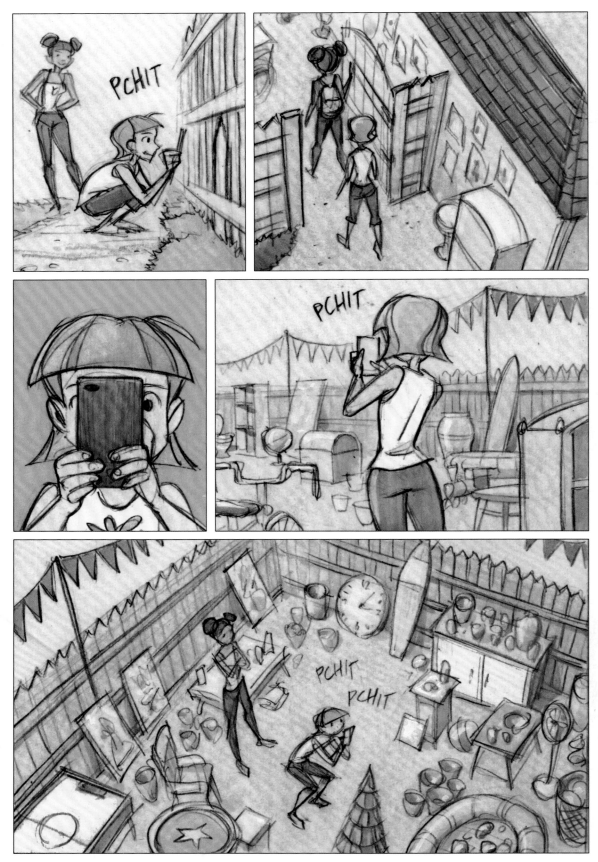

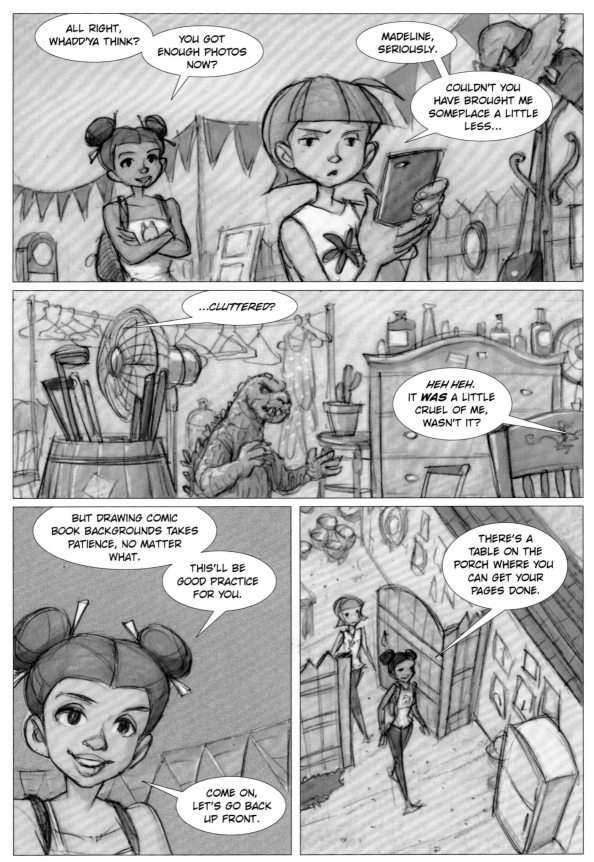

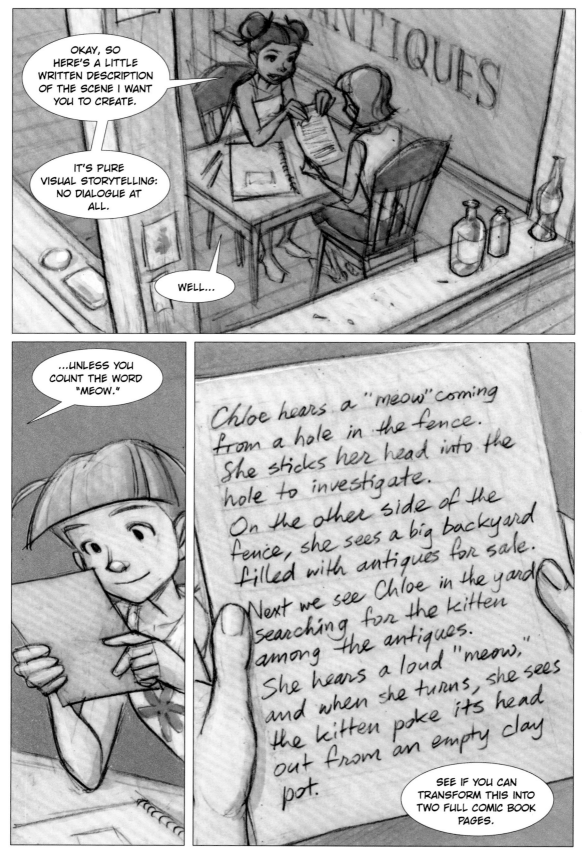

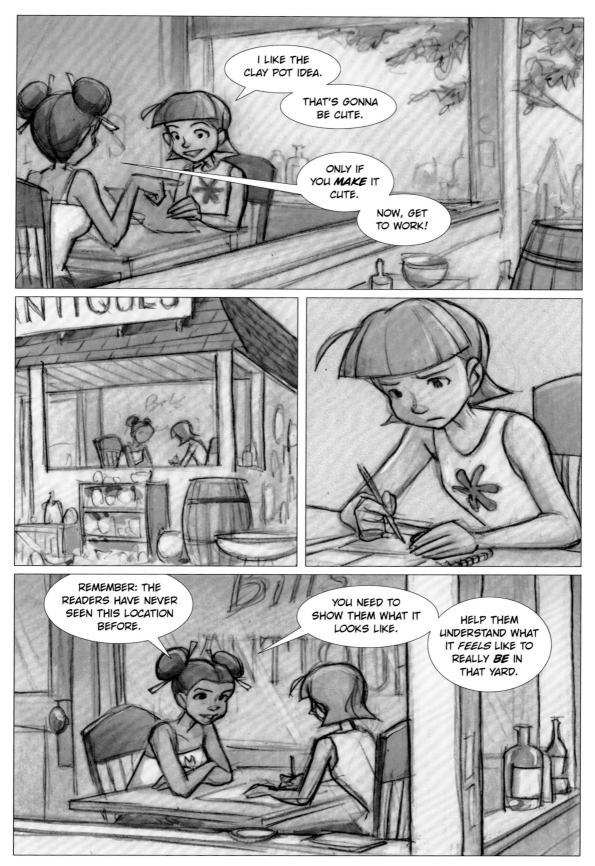

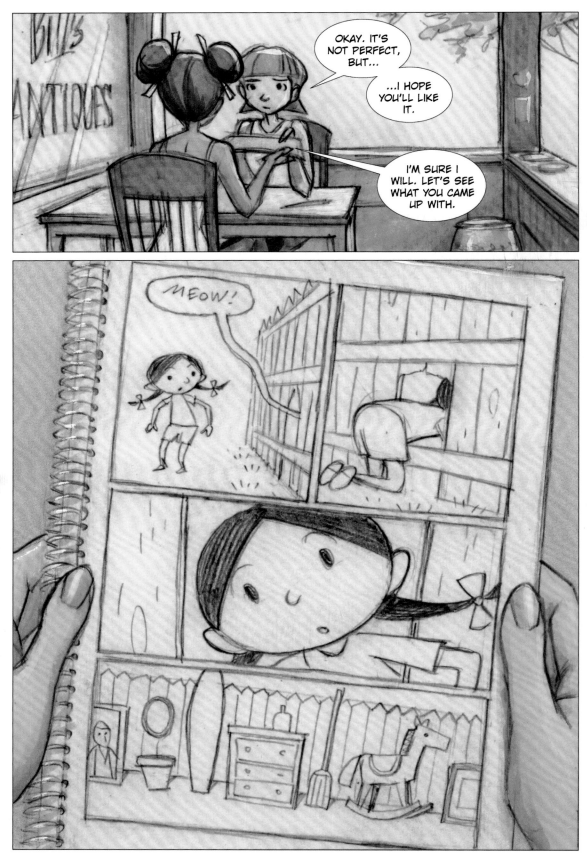

86

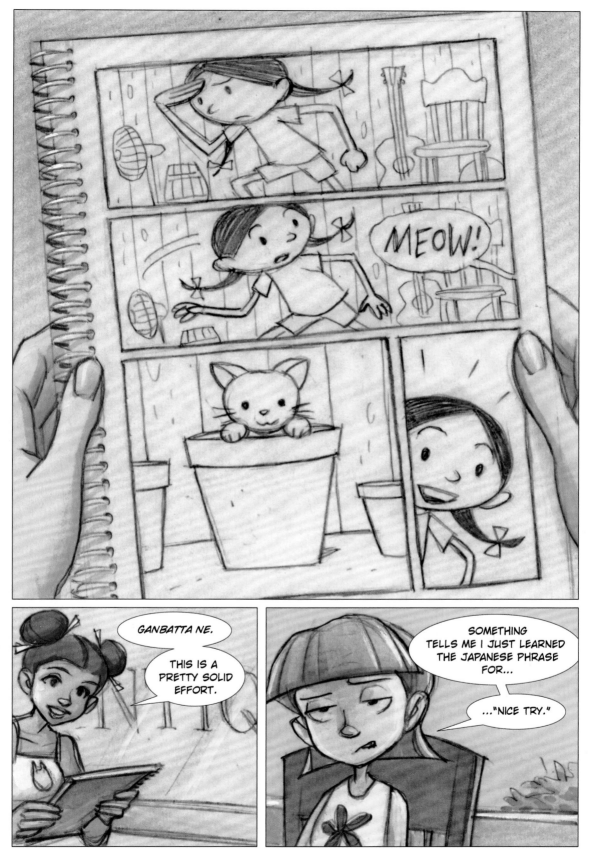

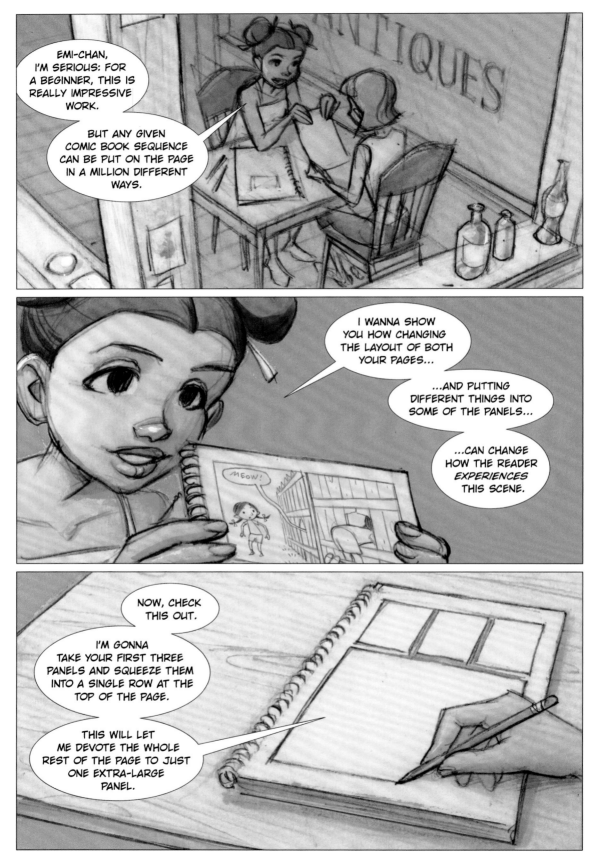

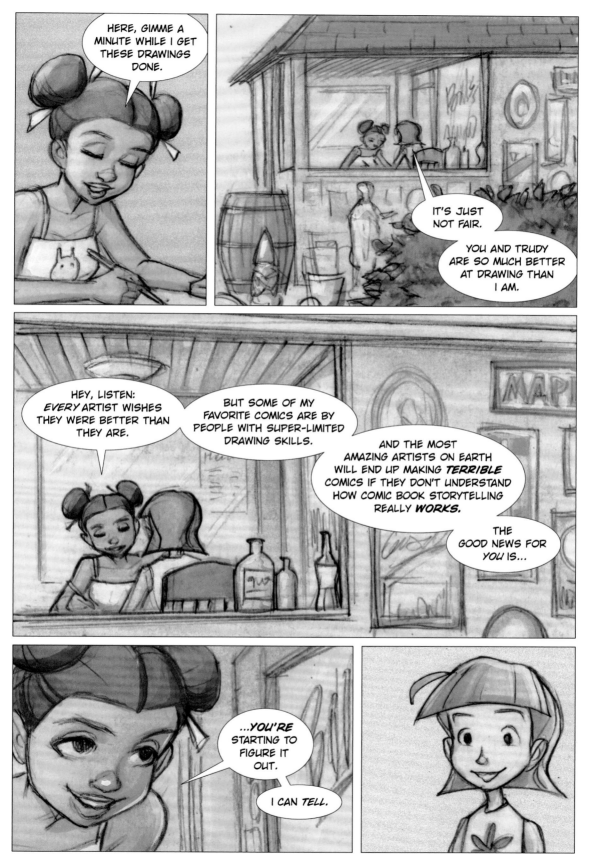

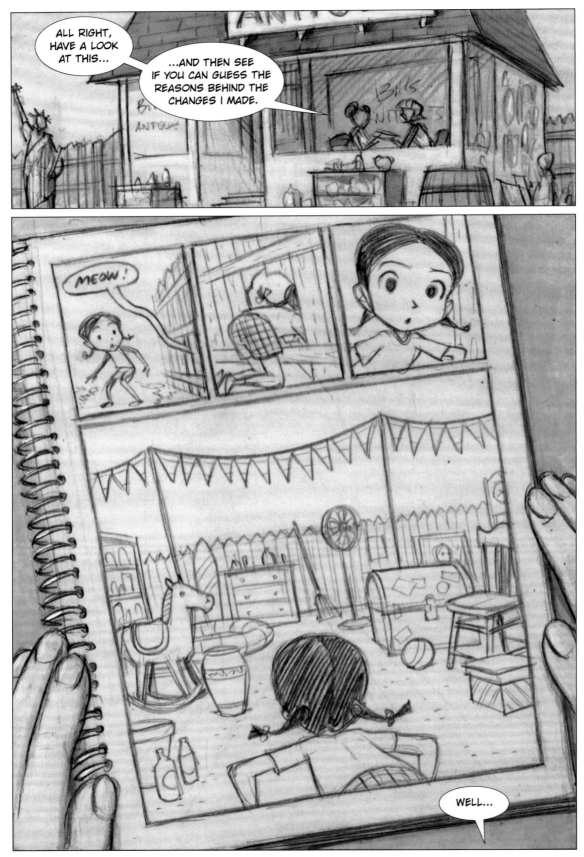

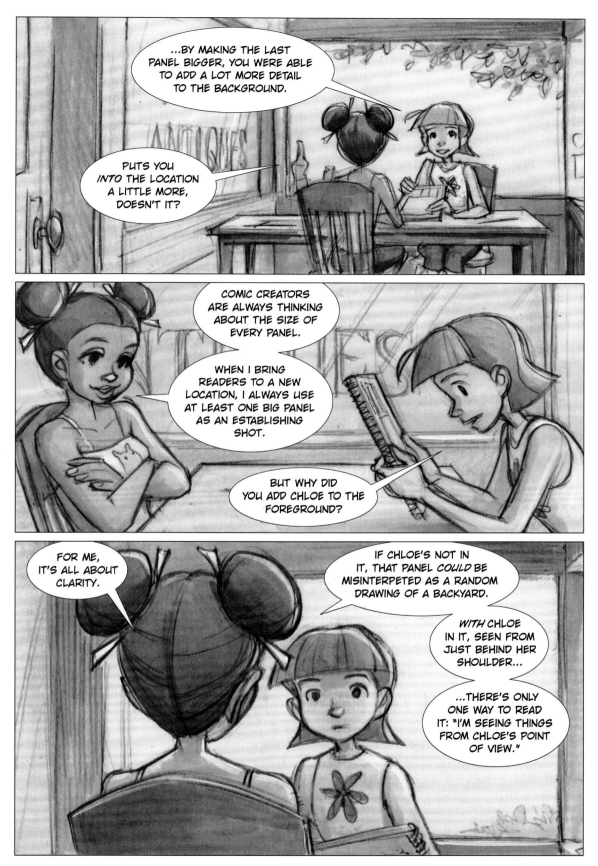

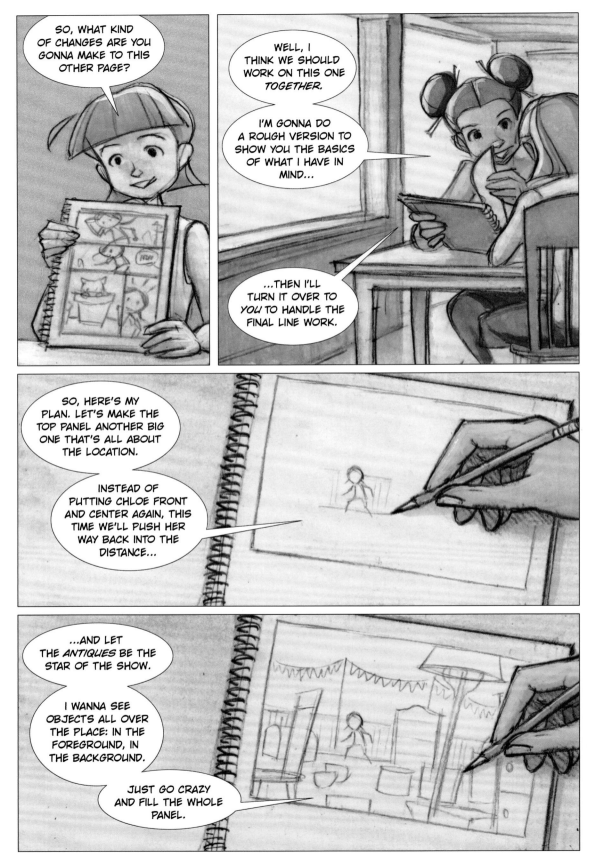

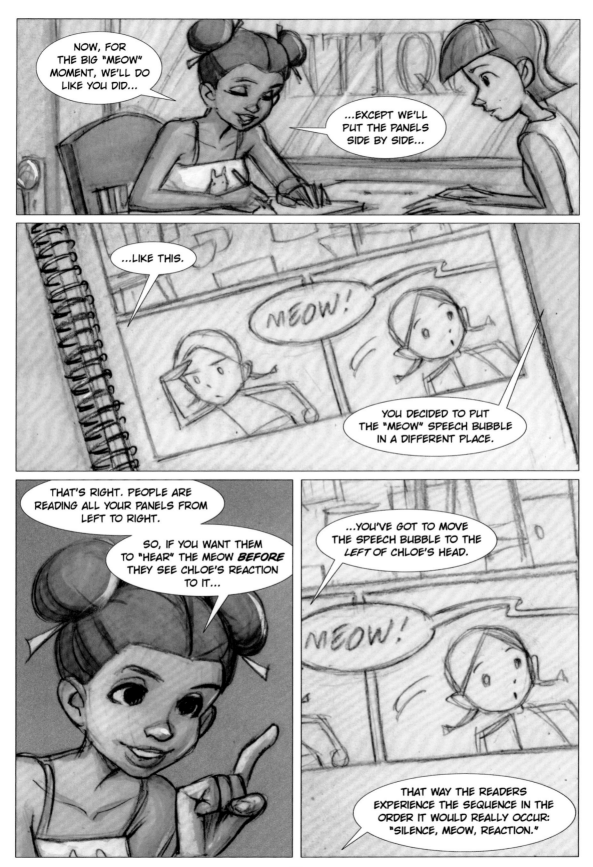

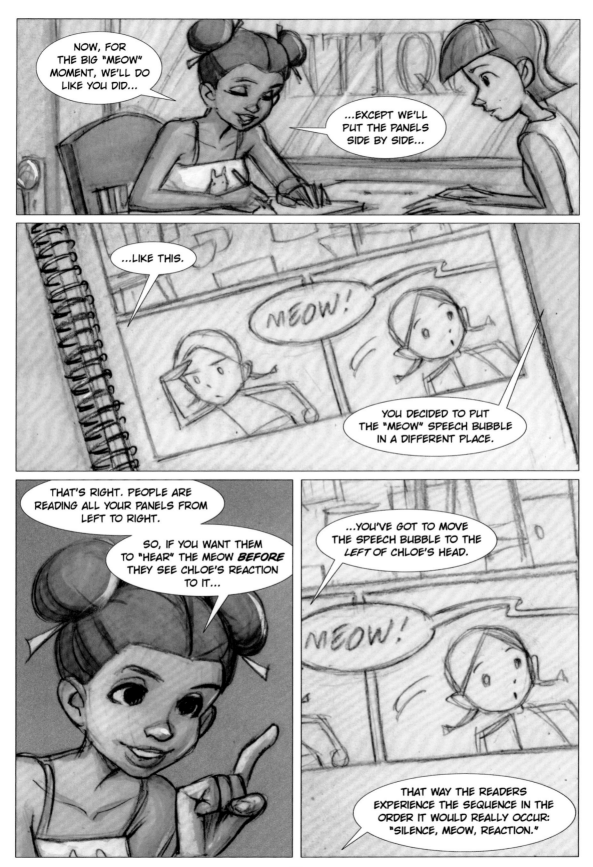

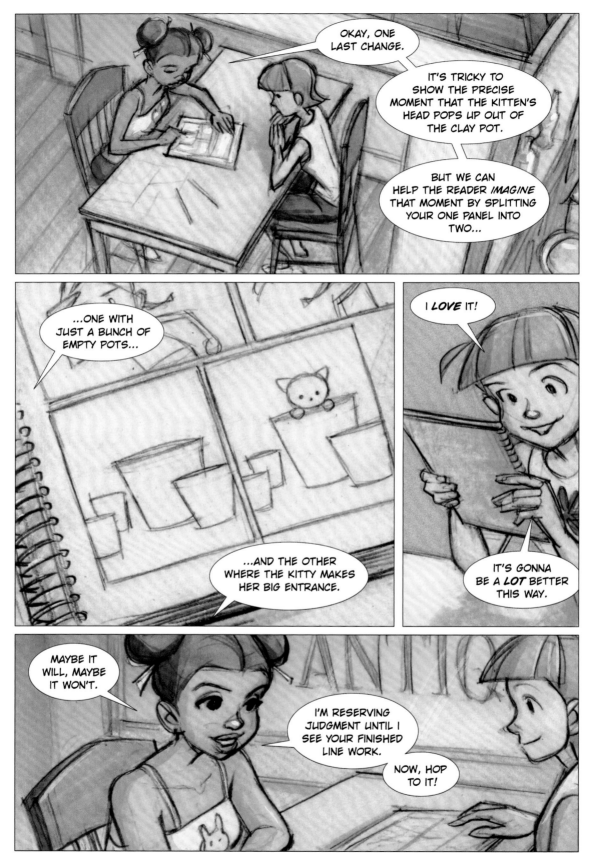

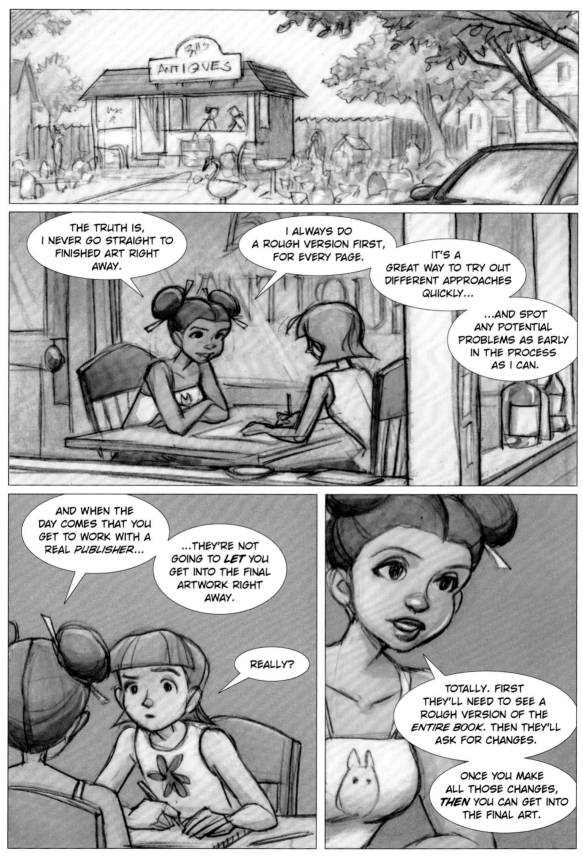

95

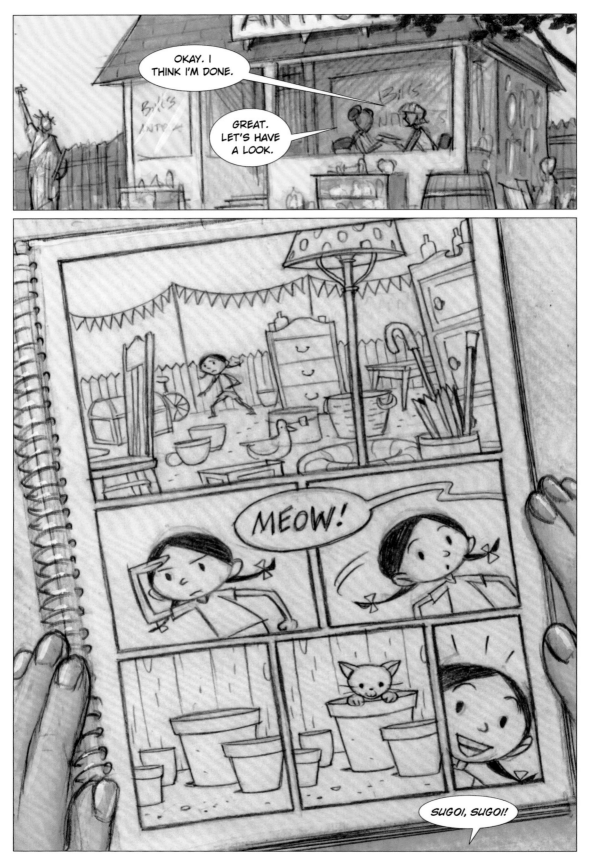

96

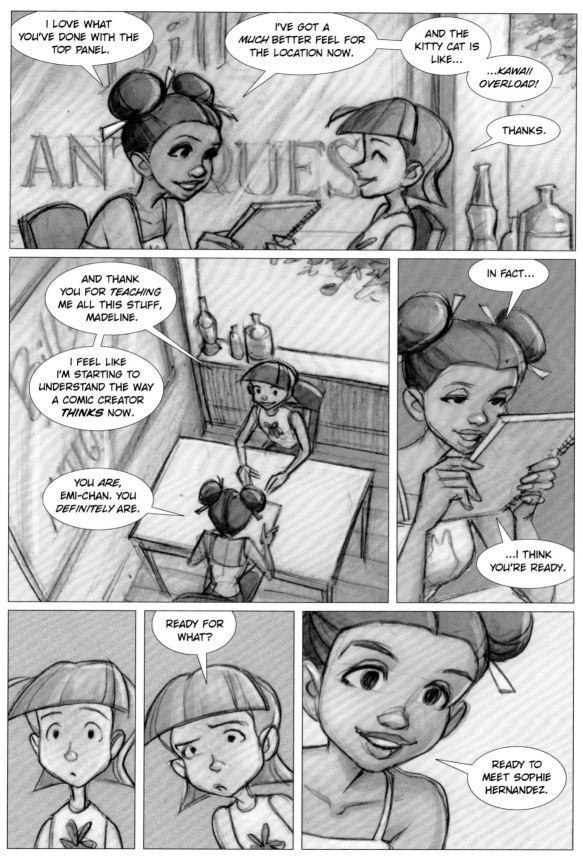

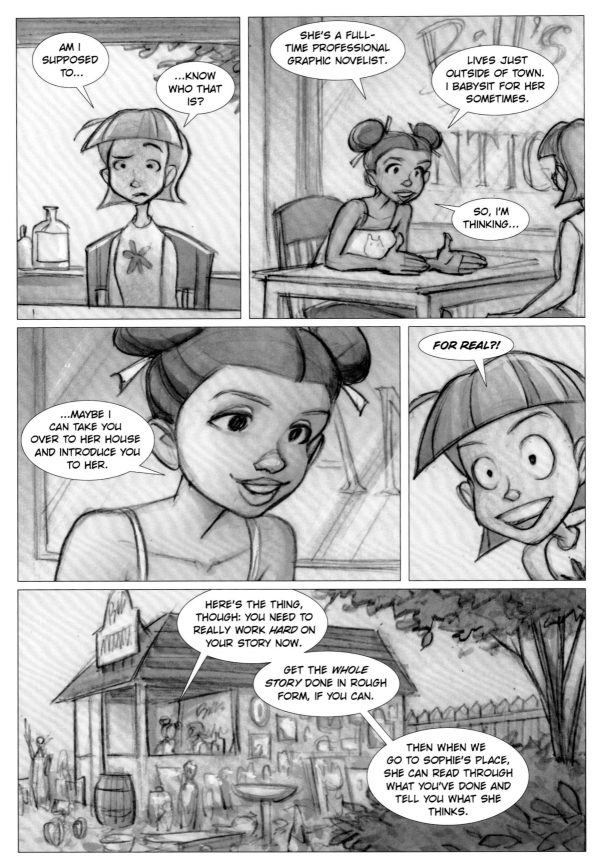

100

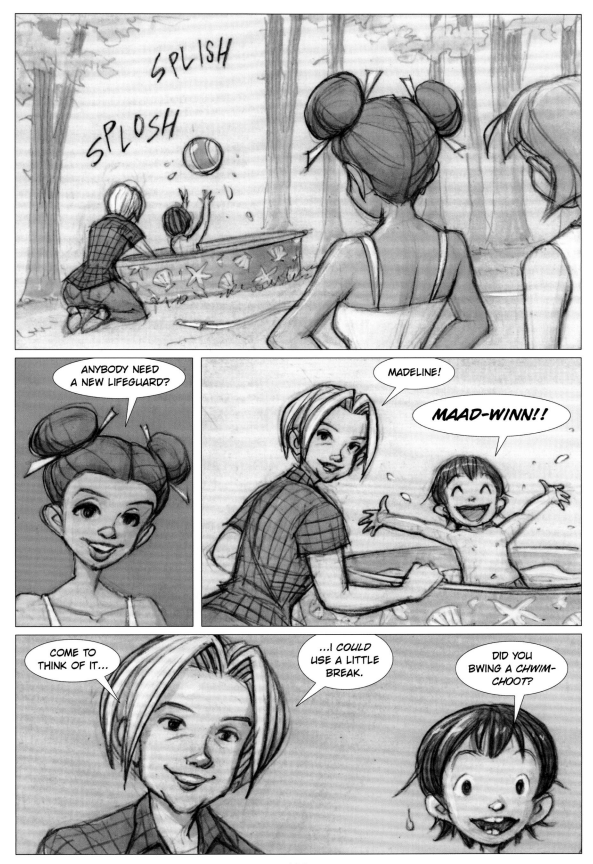

SPLISH

SPLOSH

ANYBODY NEED A NEW LIFEGUARD?

MADELINE!

MAAD-WINN!!

COME TO THINK OF IT...

...I COULD USE A LITTLE BREAK.

DID YOU BWING A CHWIM-CHOOT?

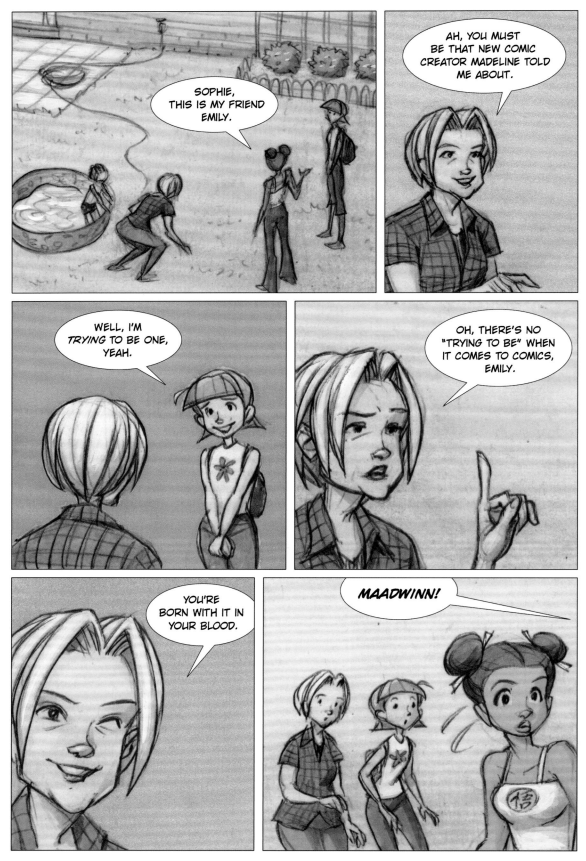

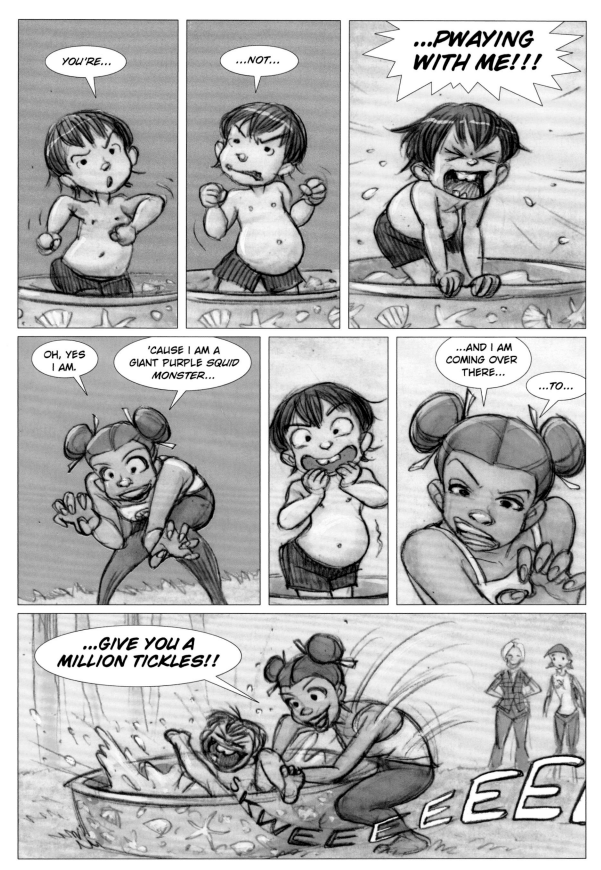

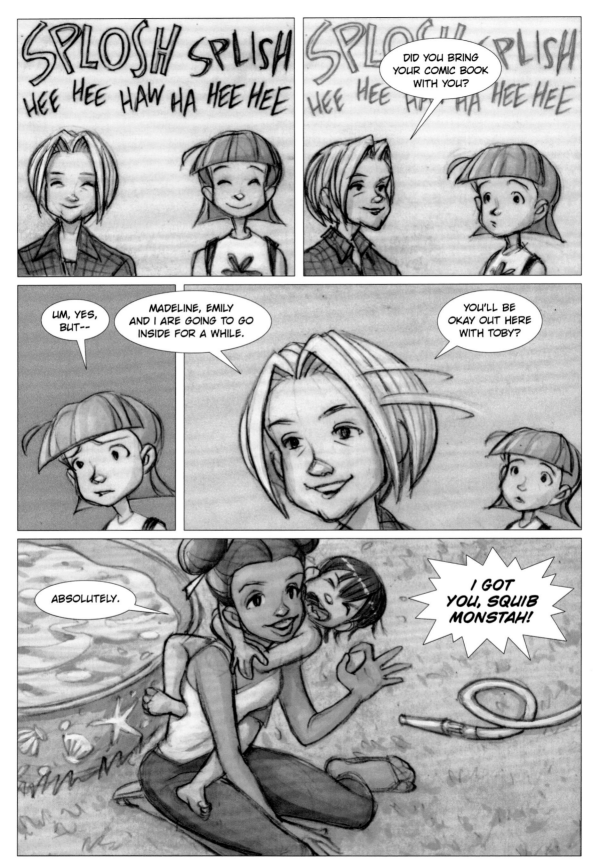

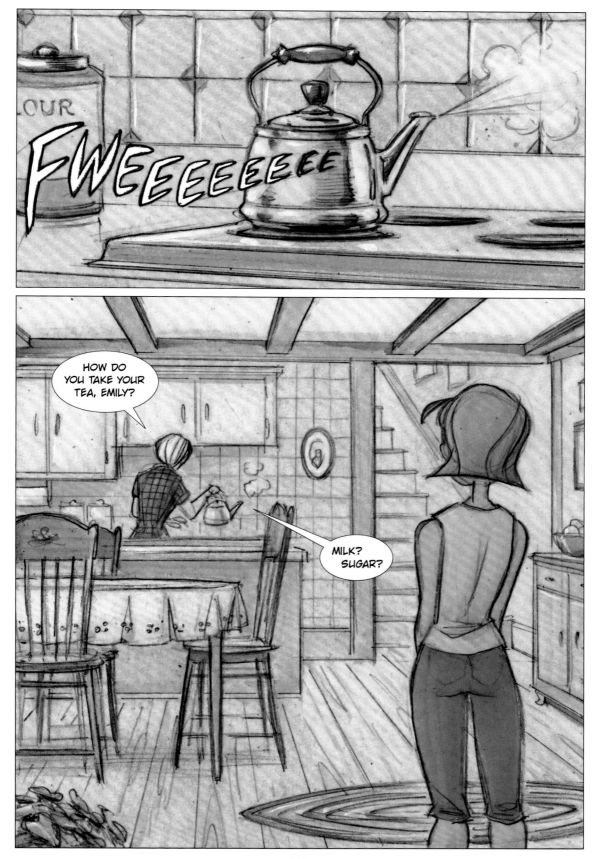

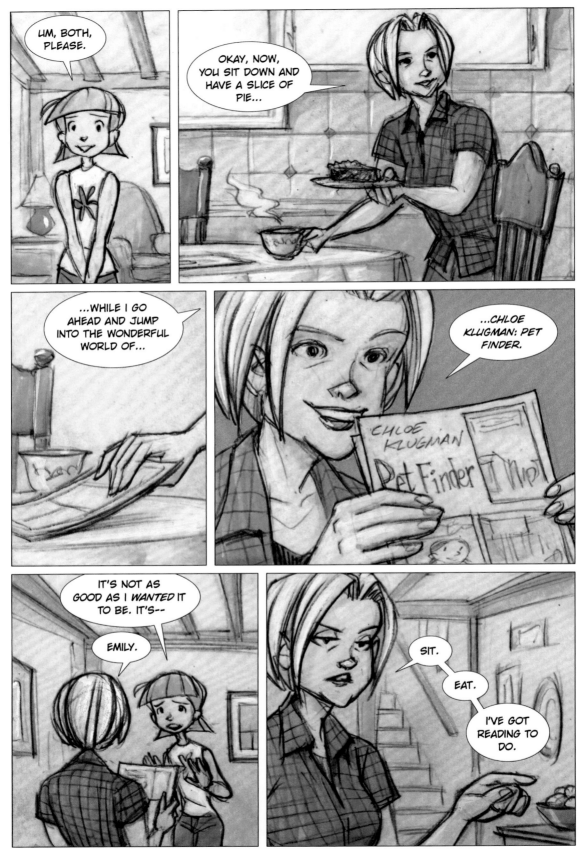

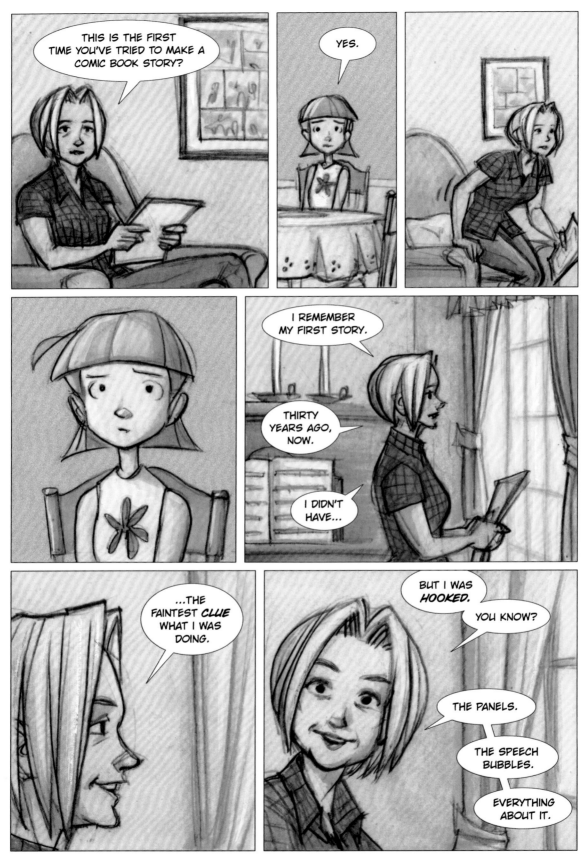

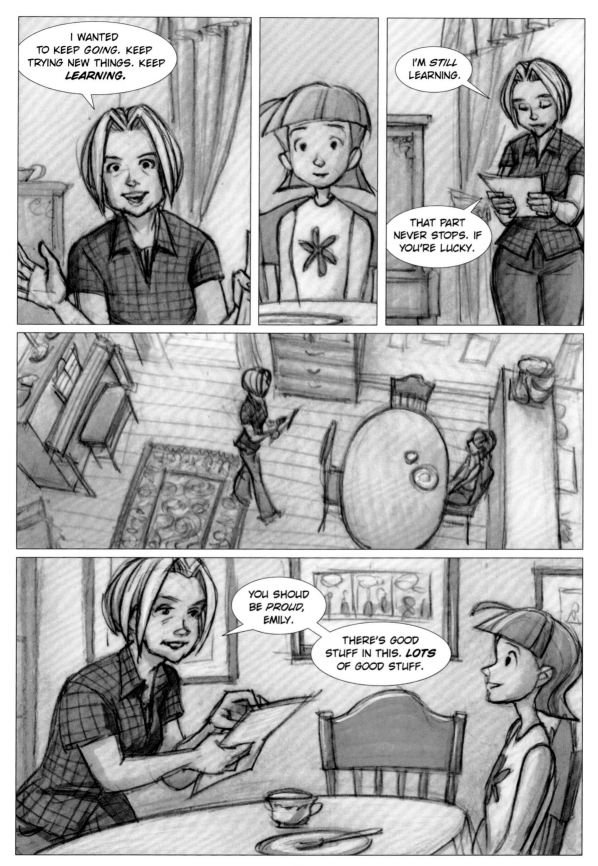

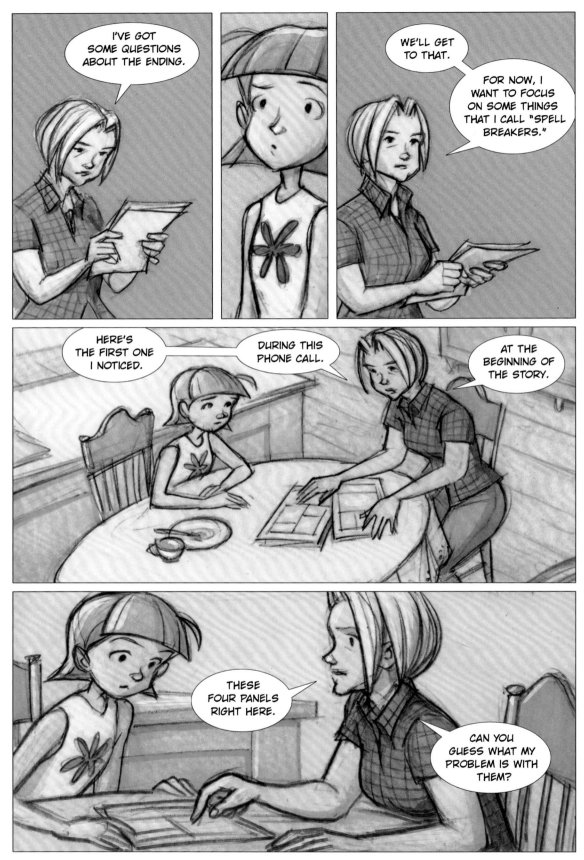

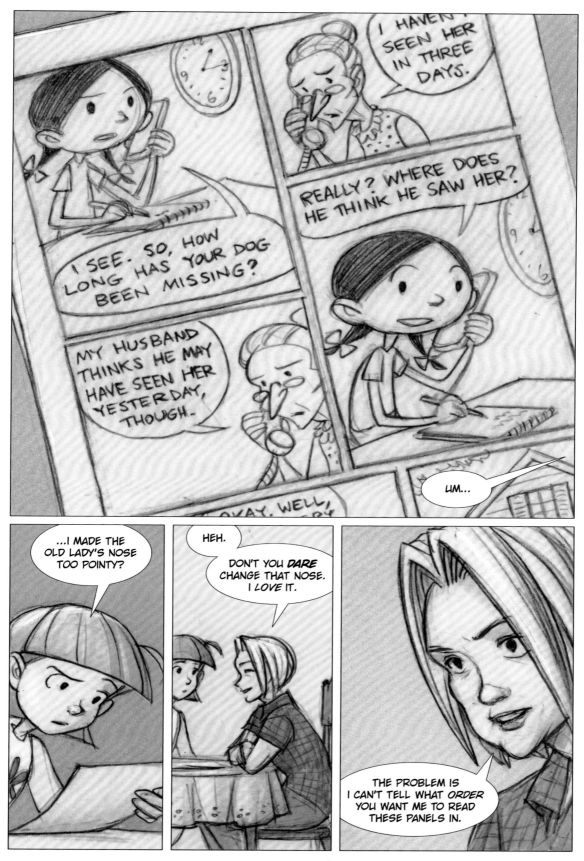

113

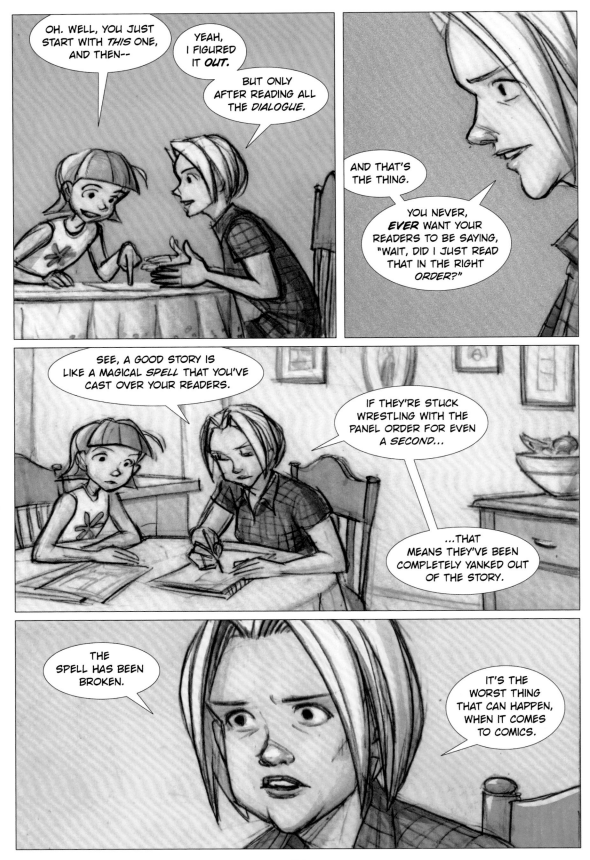

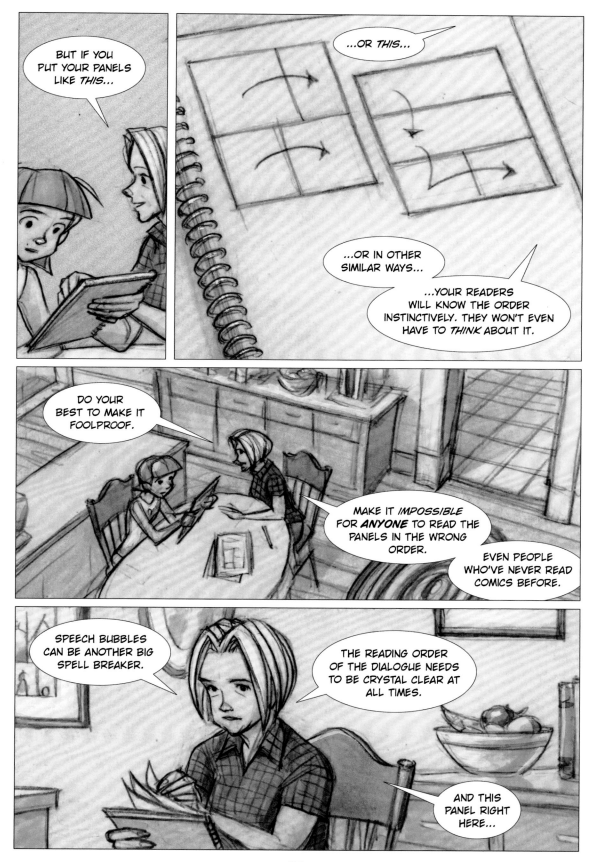

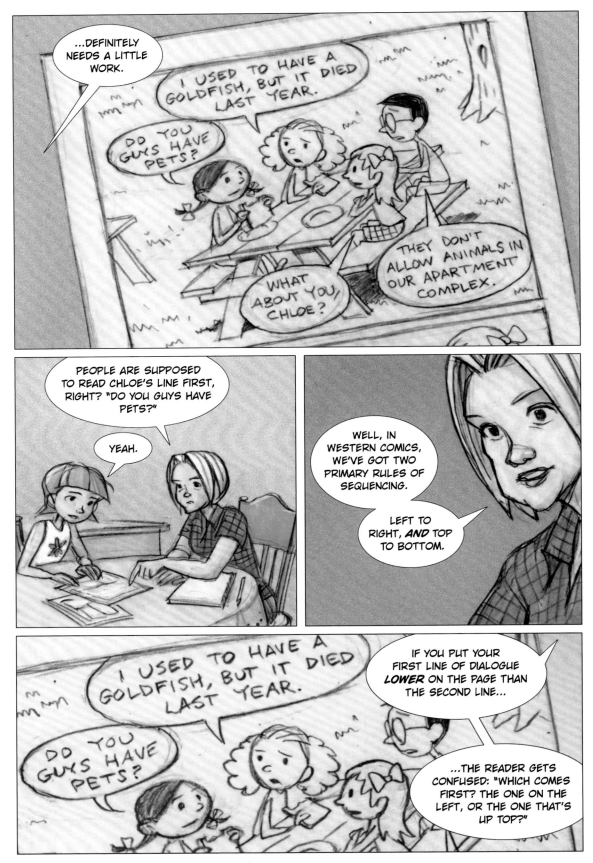

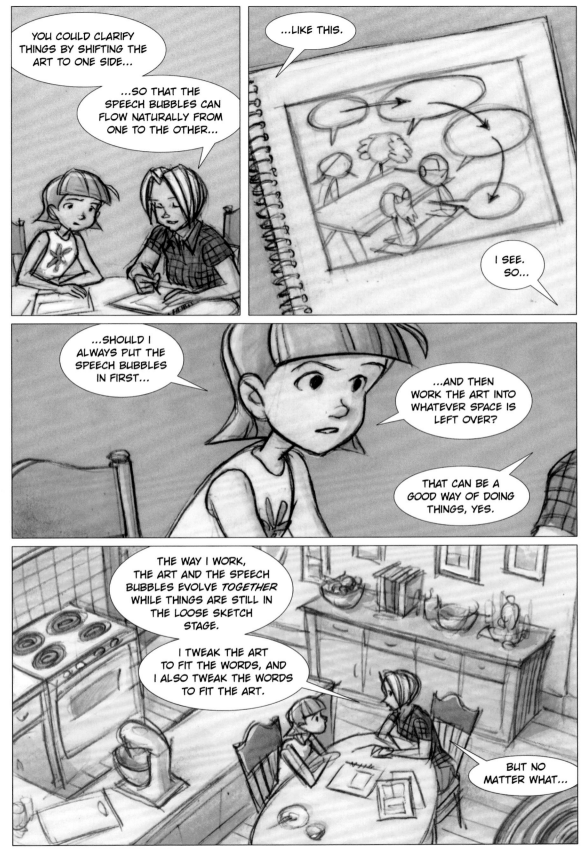

117

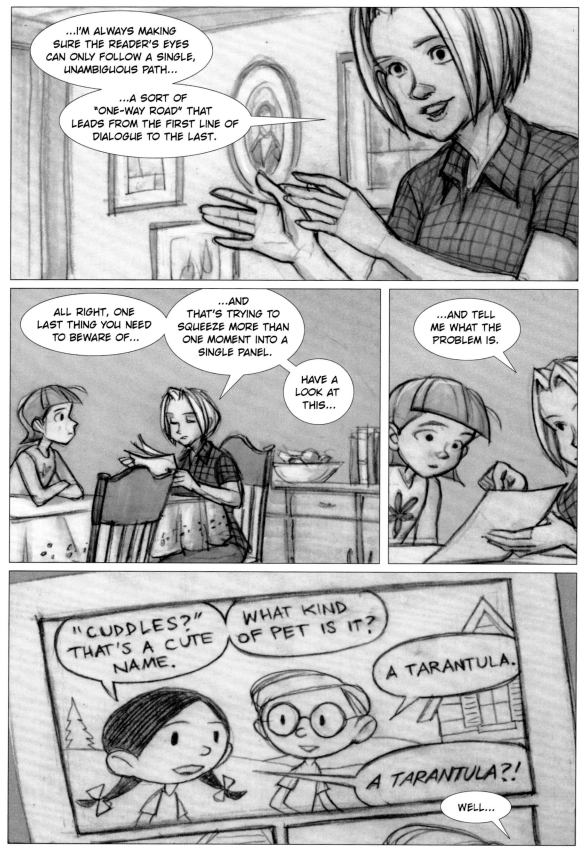

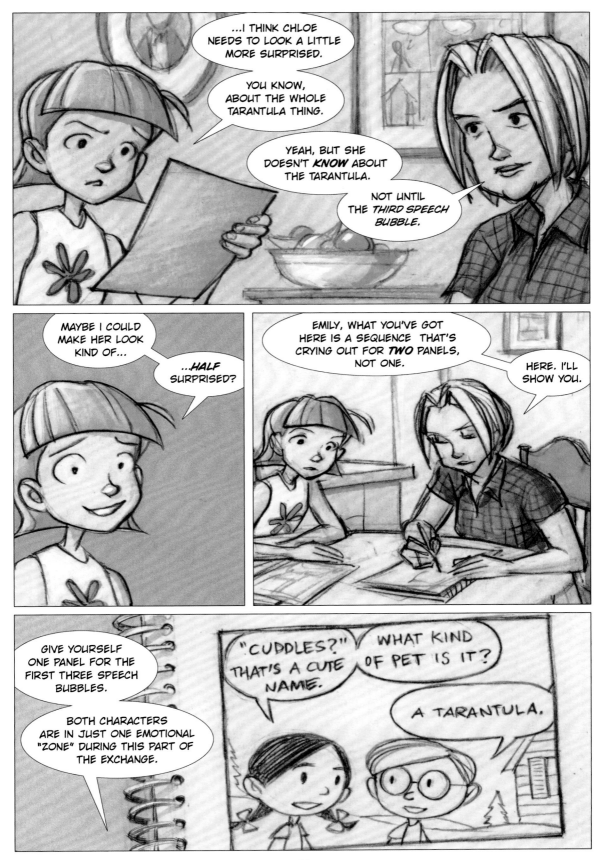

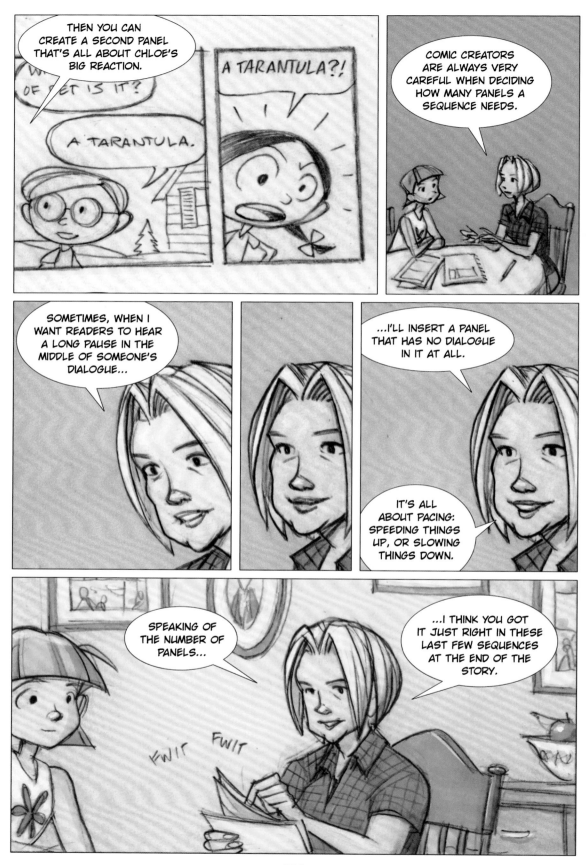

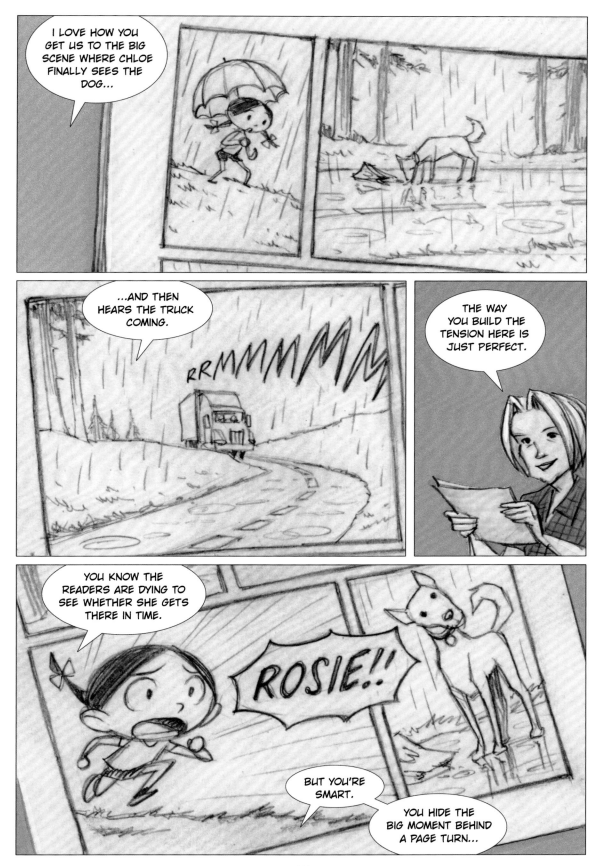

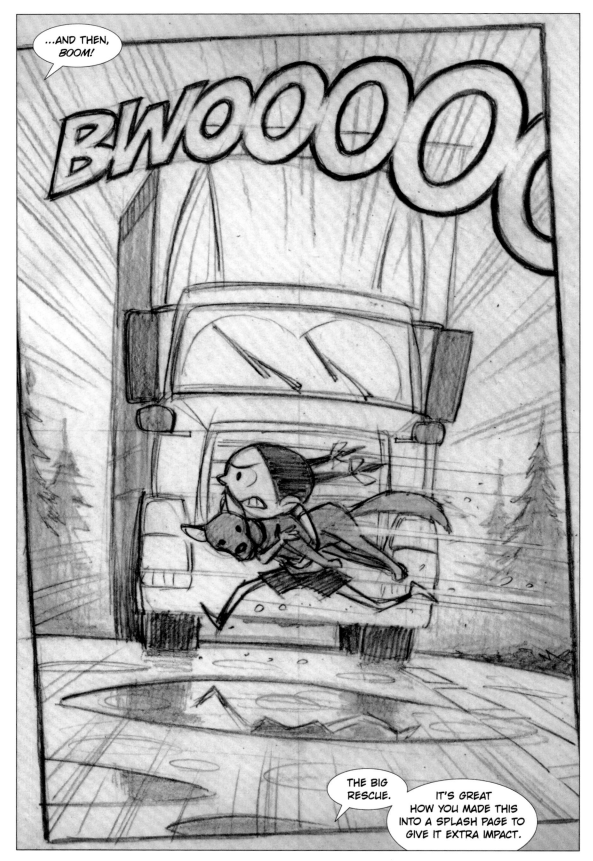

122

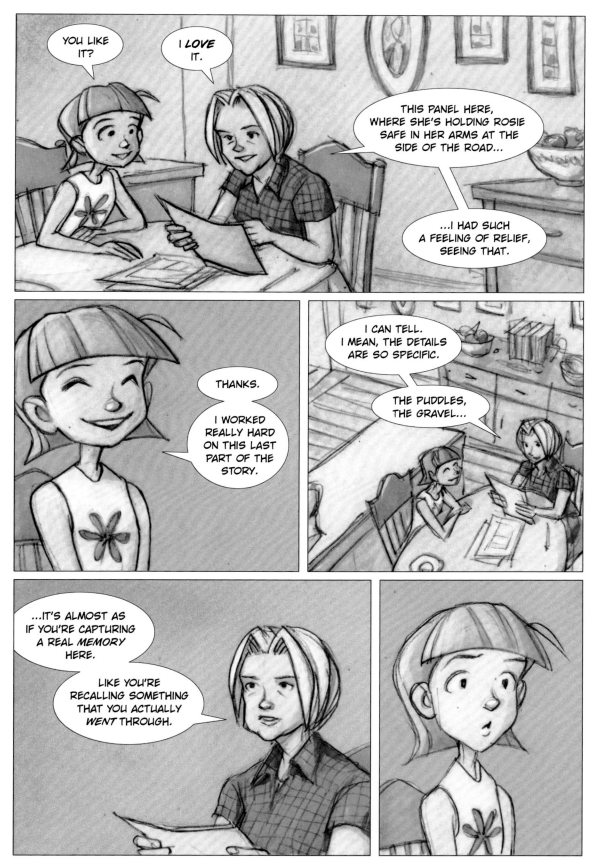

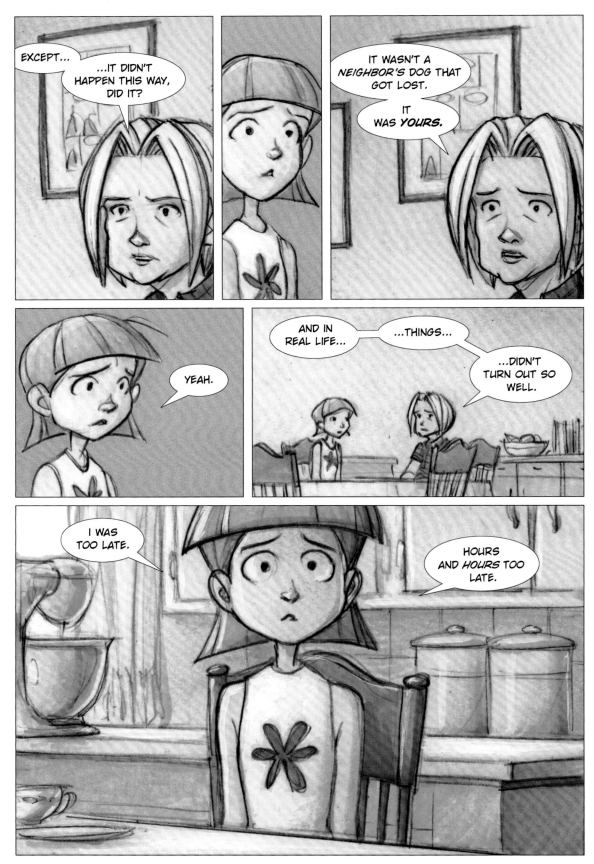

124

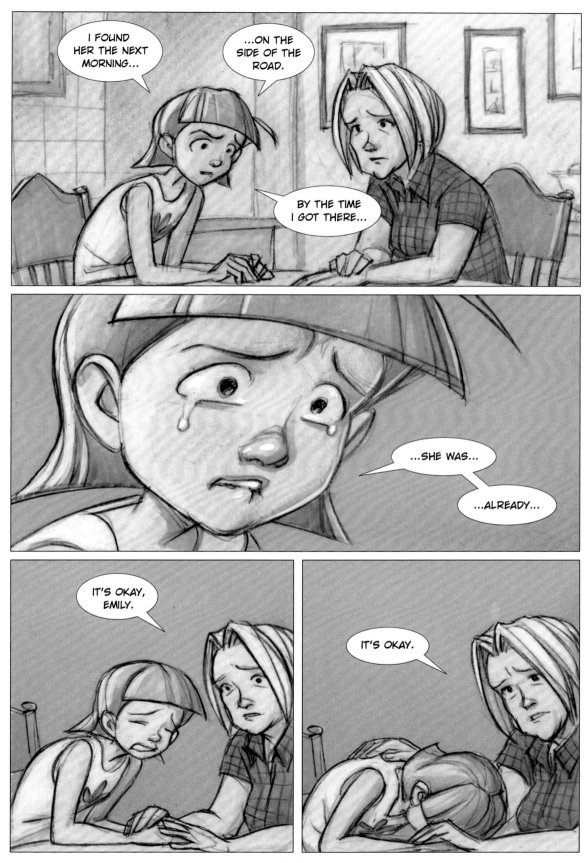

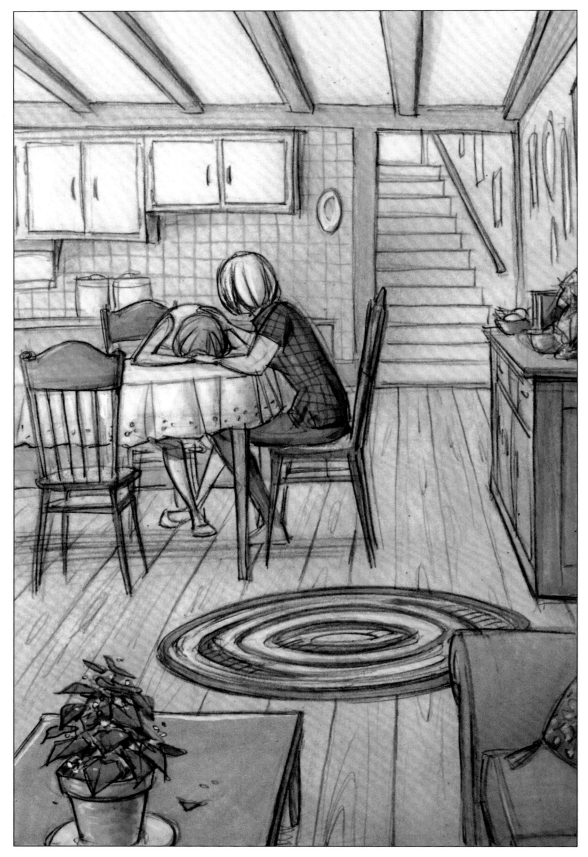

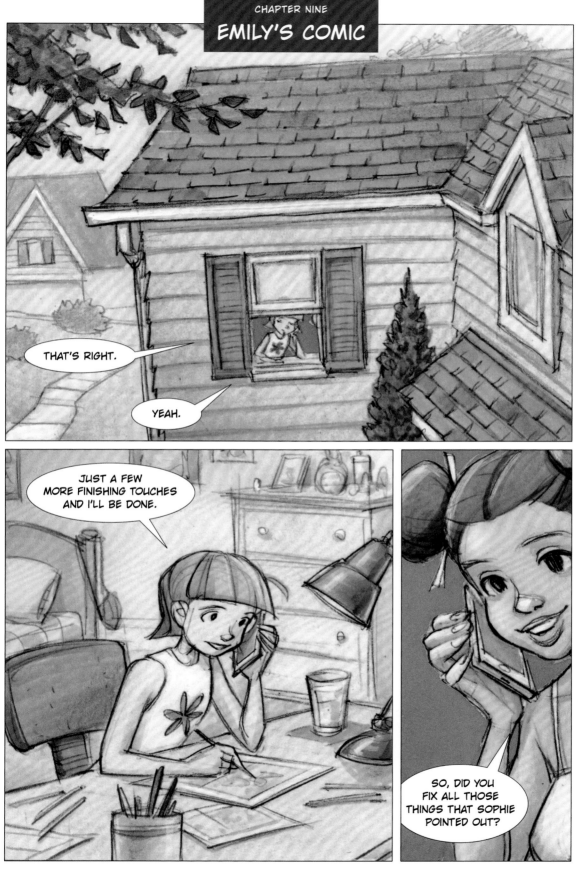

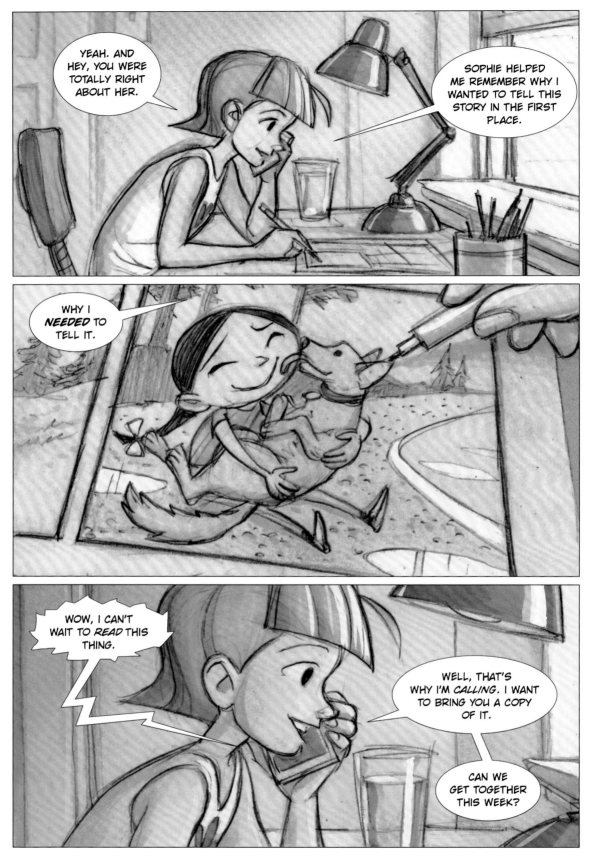

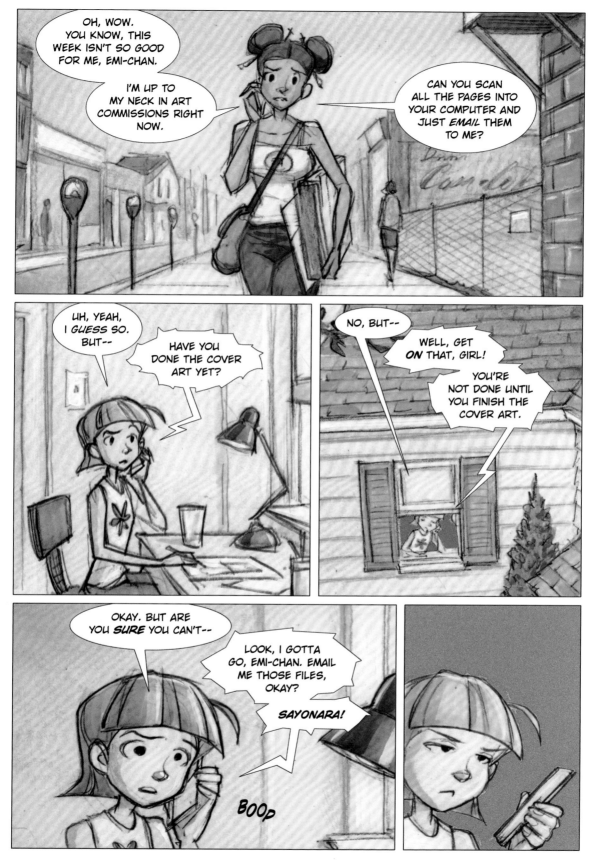

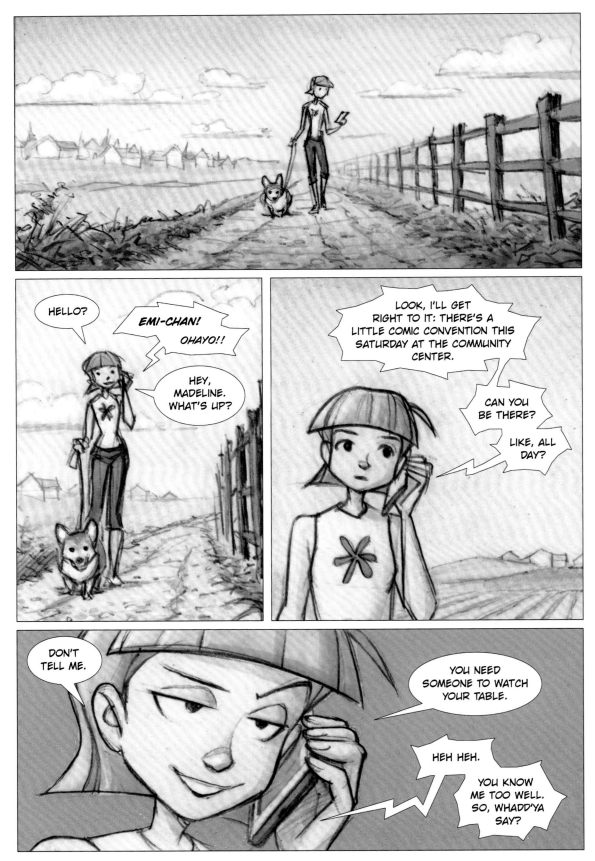

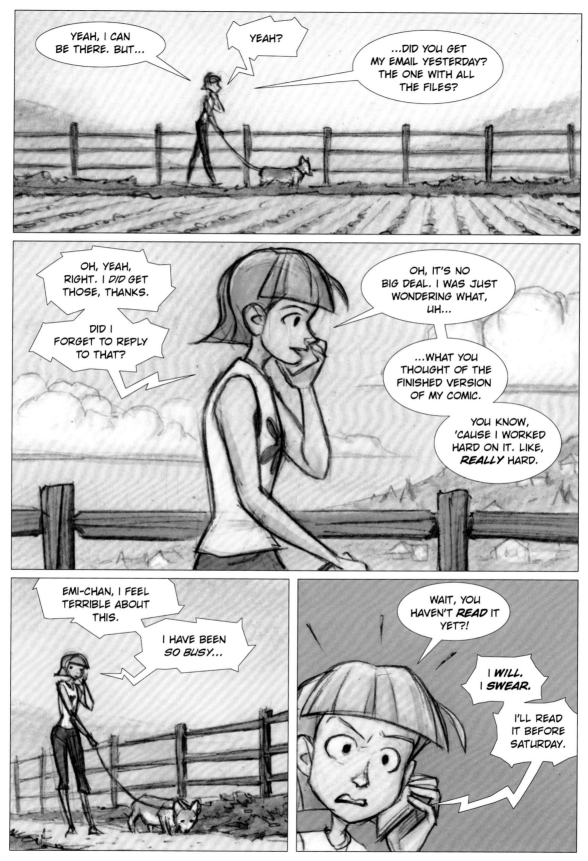

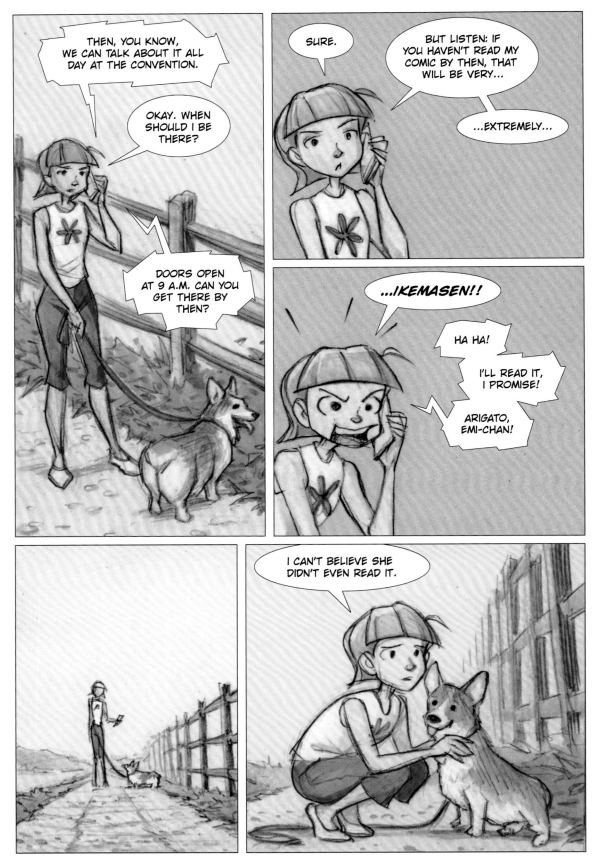

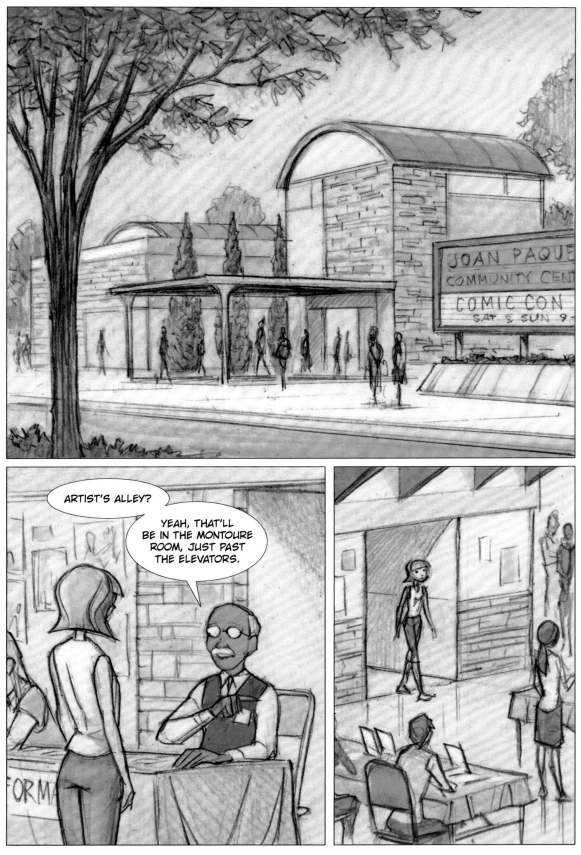

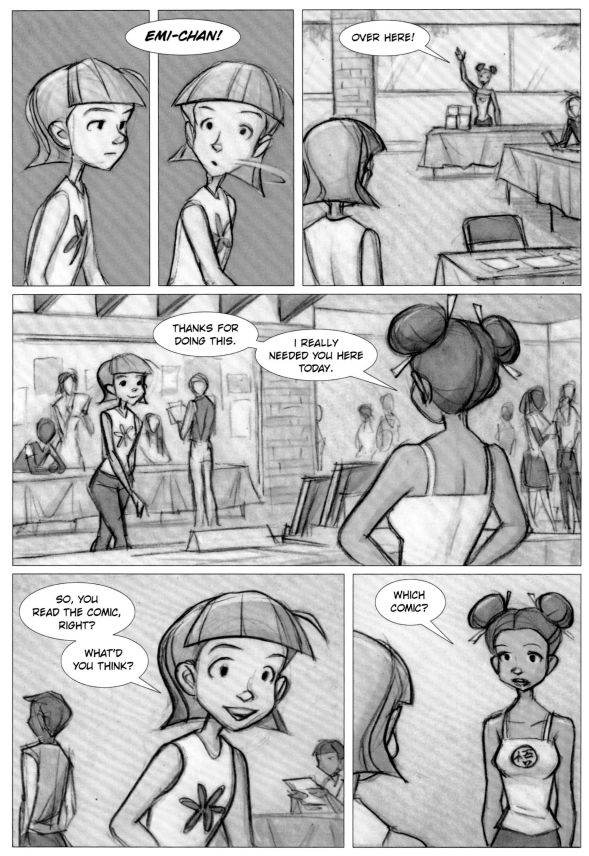

134

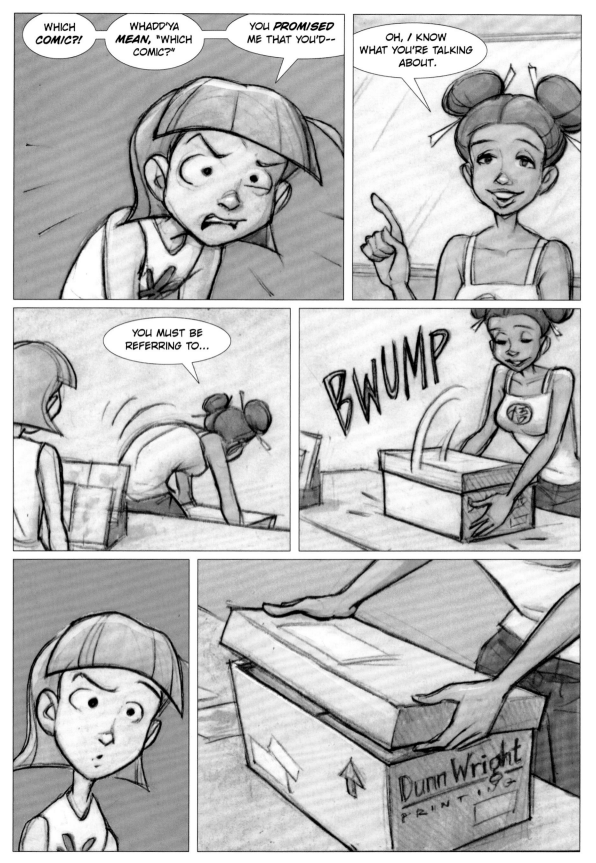

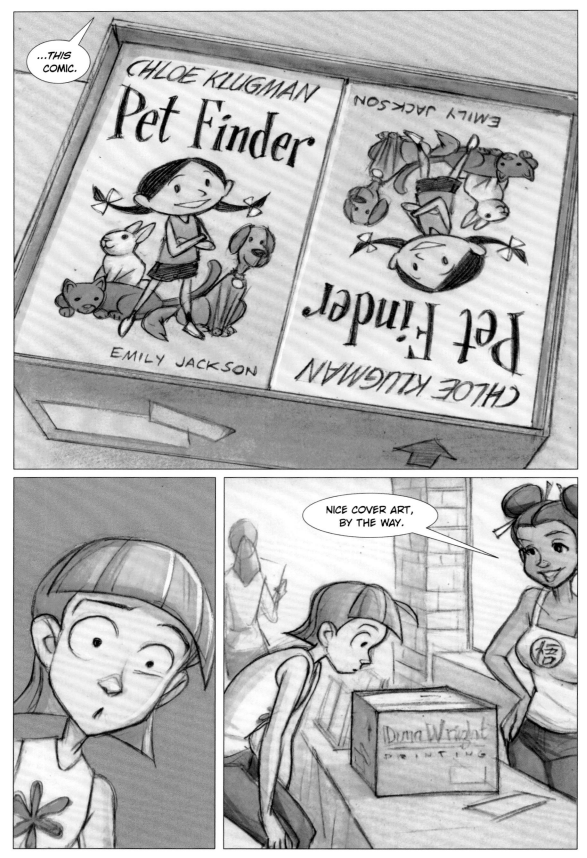

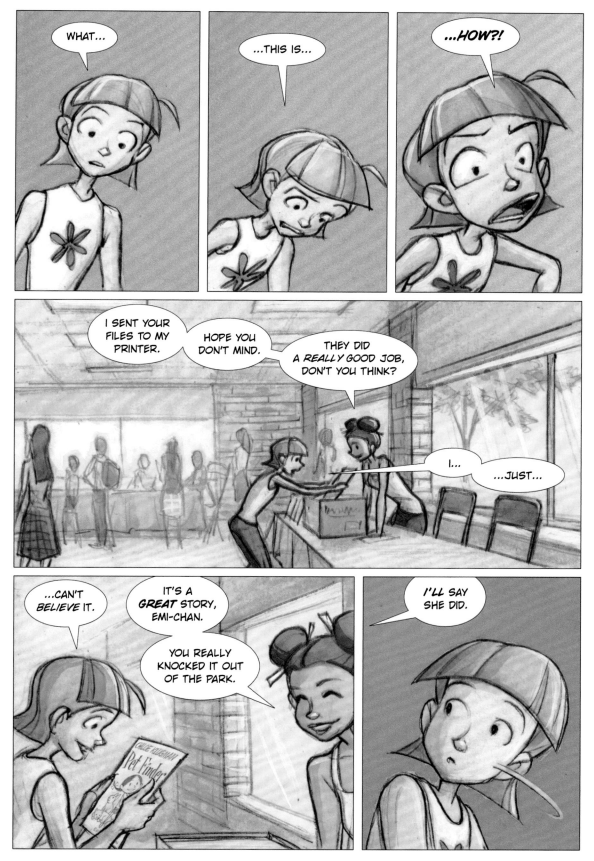

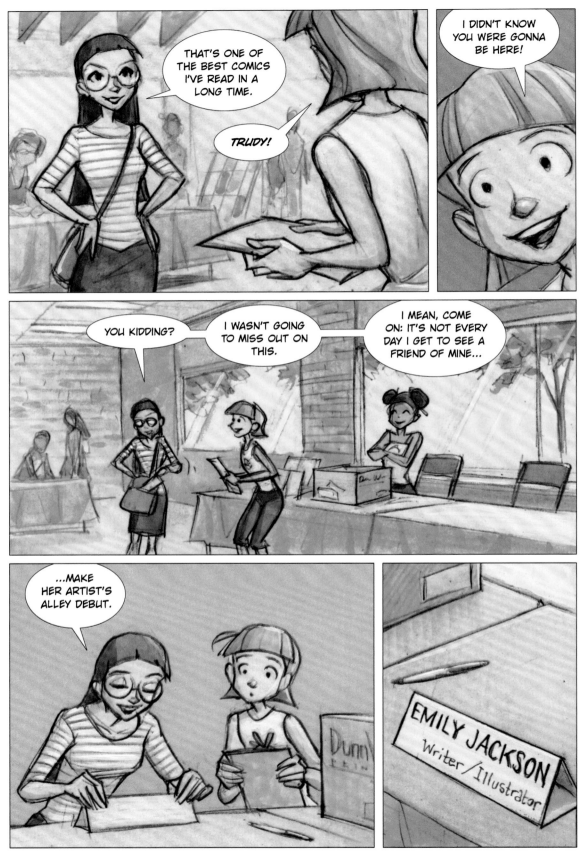

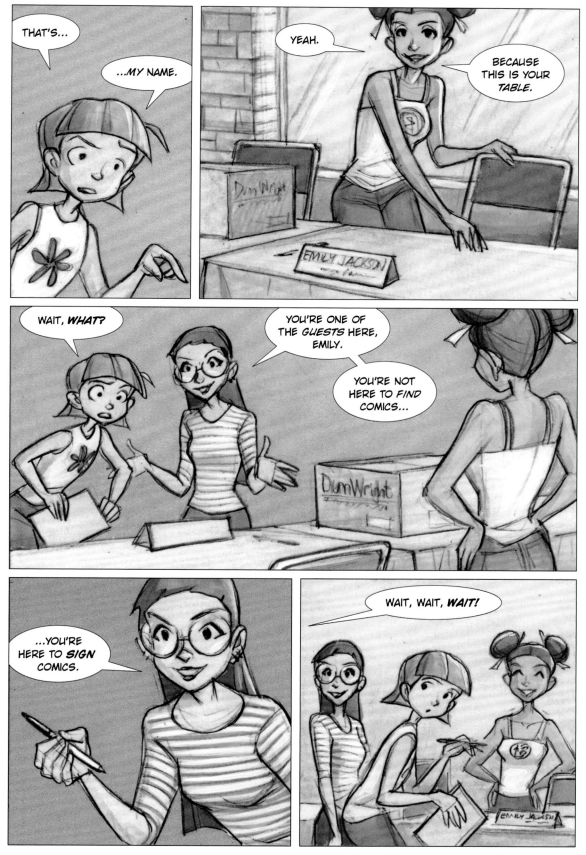

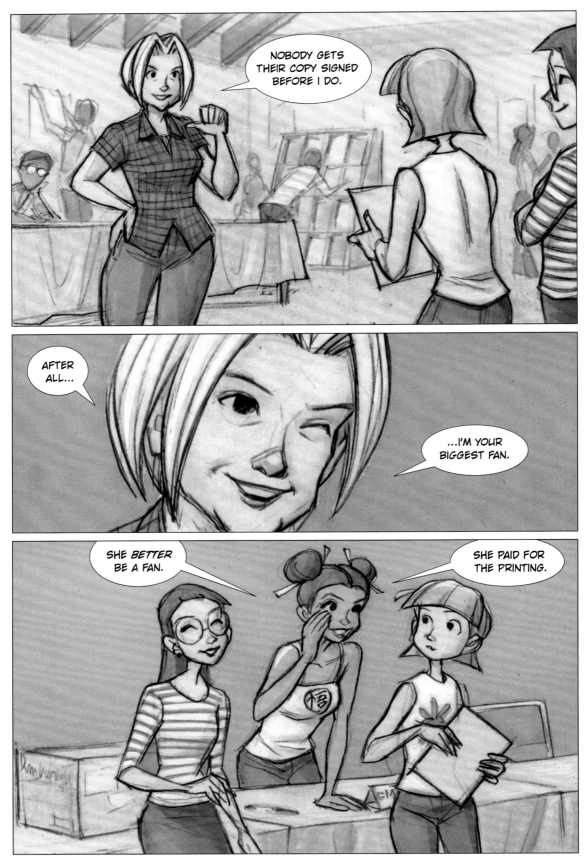

140

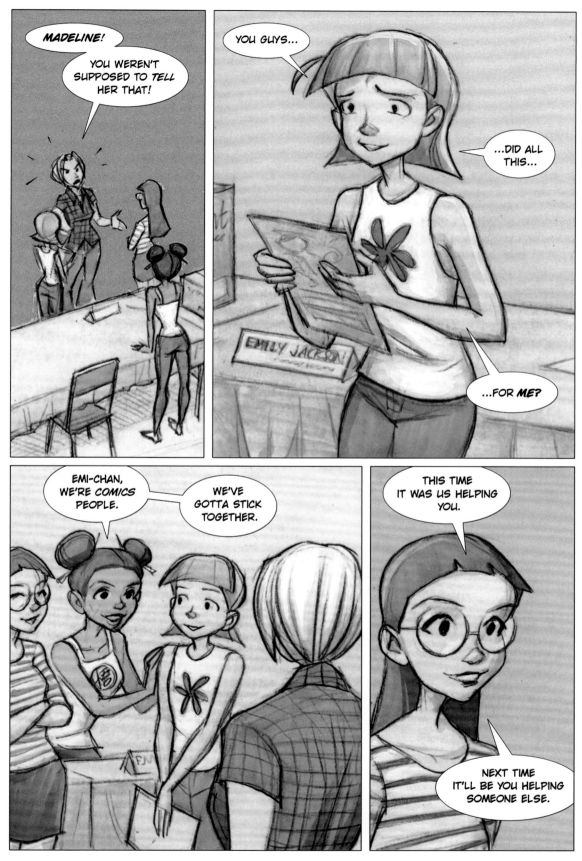

141

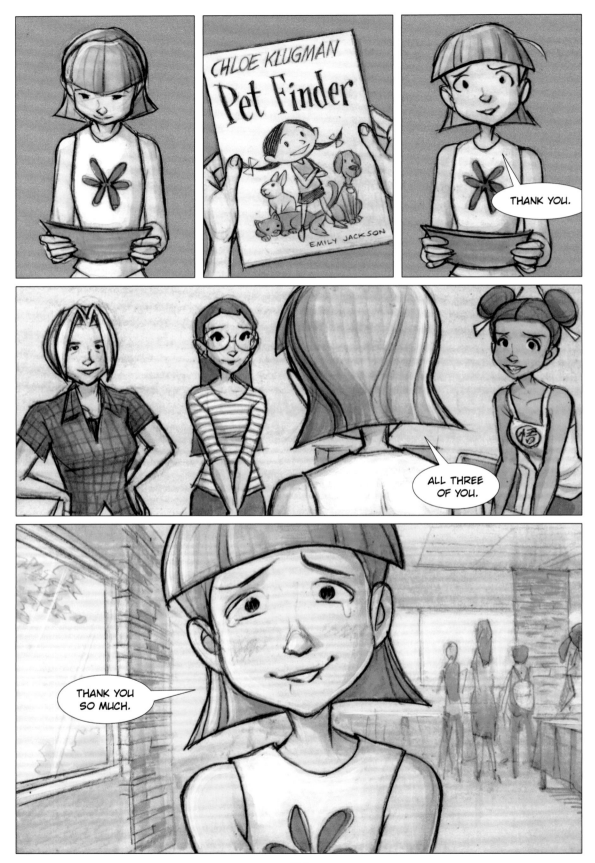

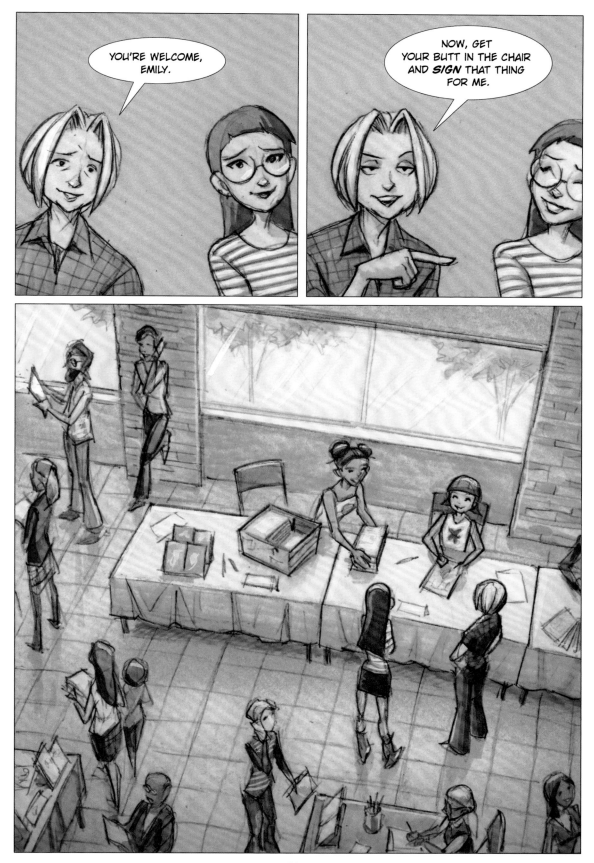

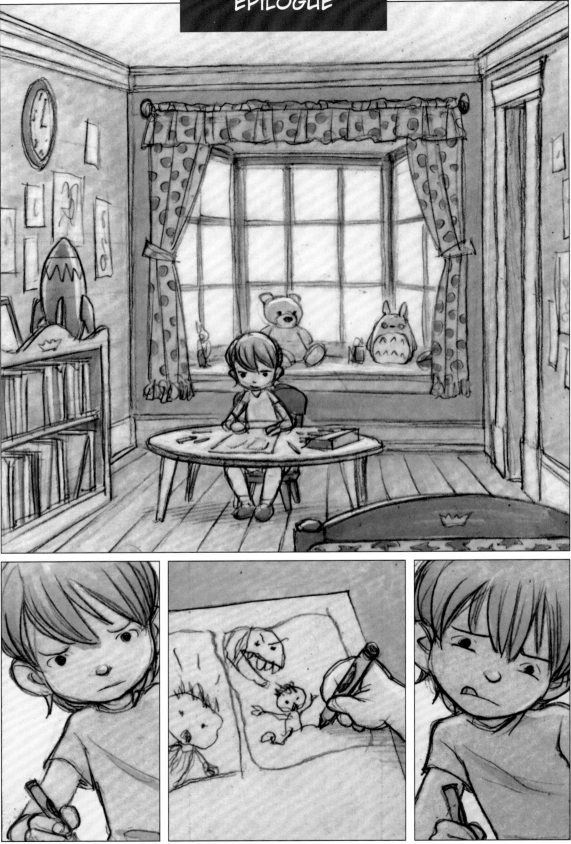

EPILOGUE

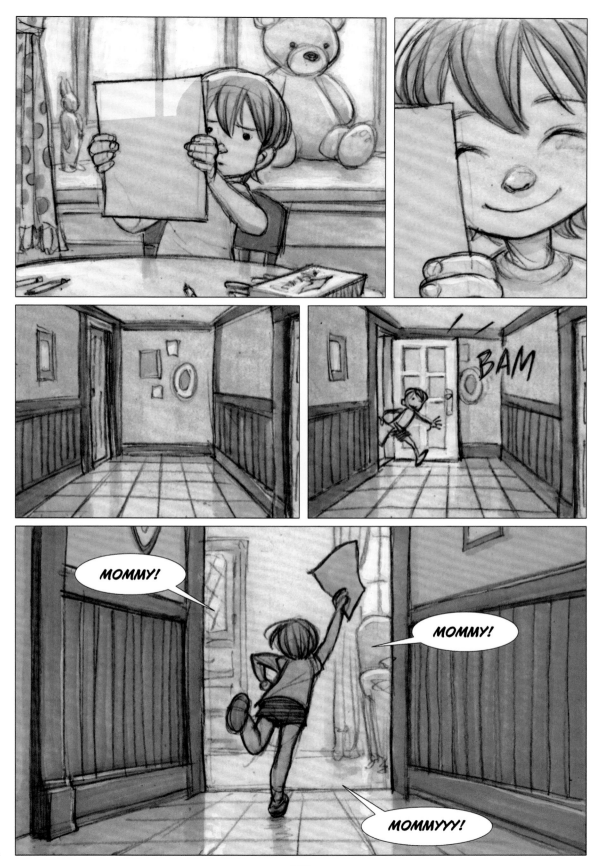

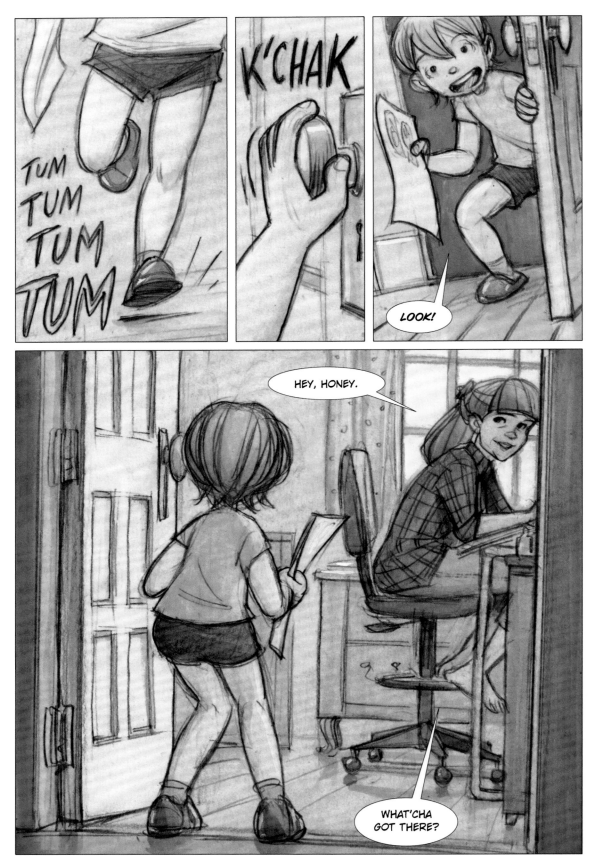

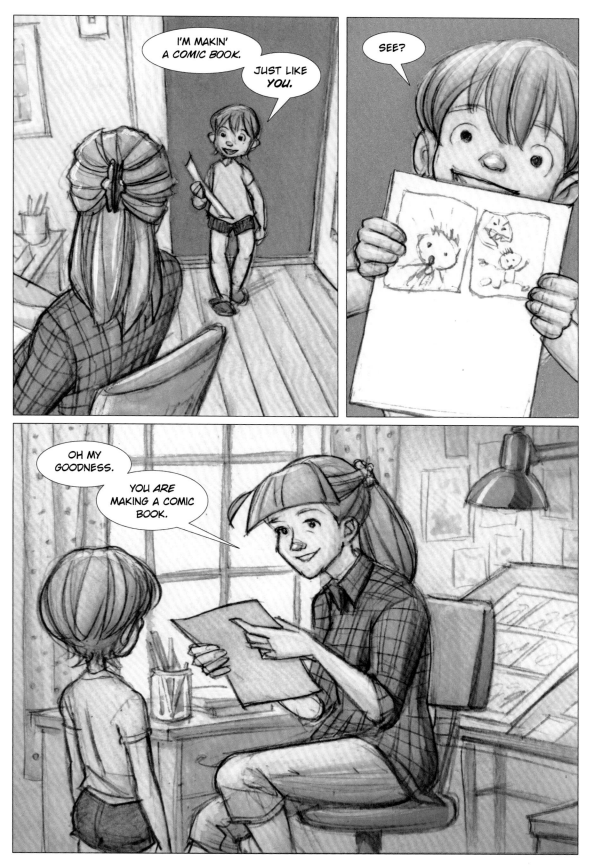

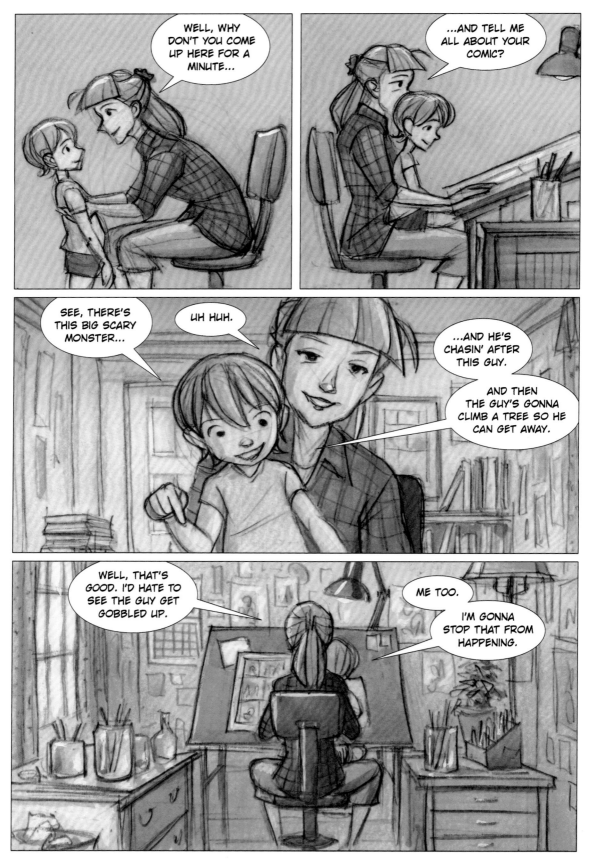

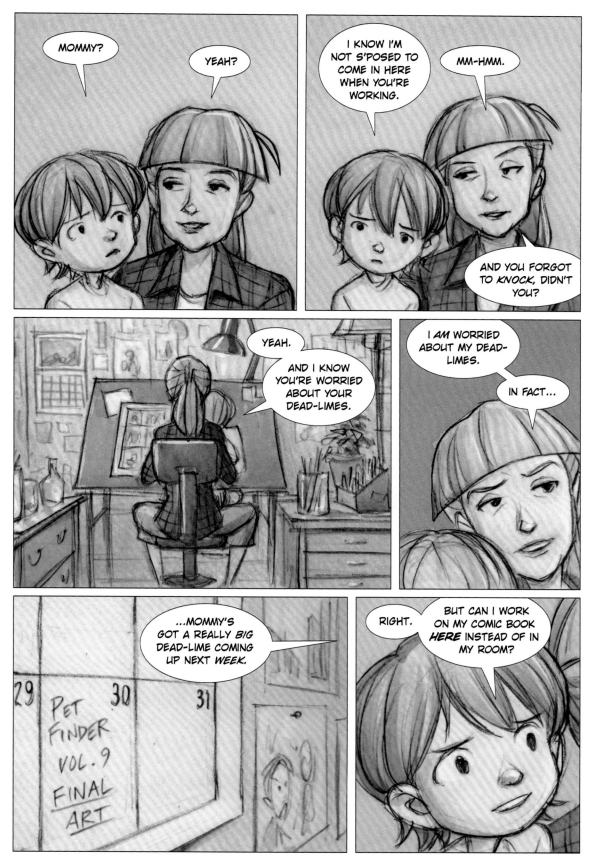

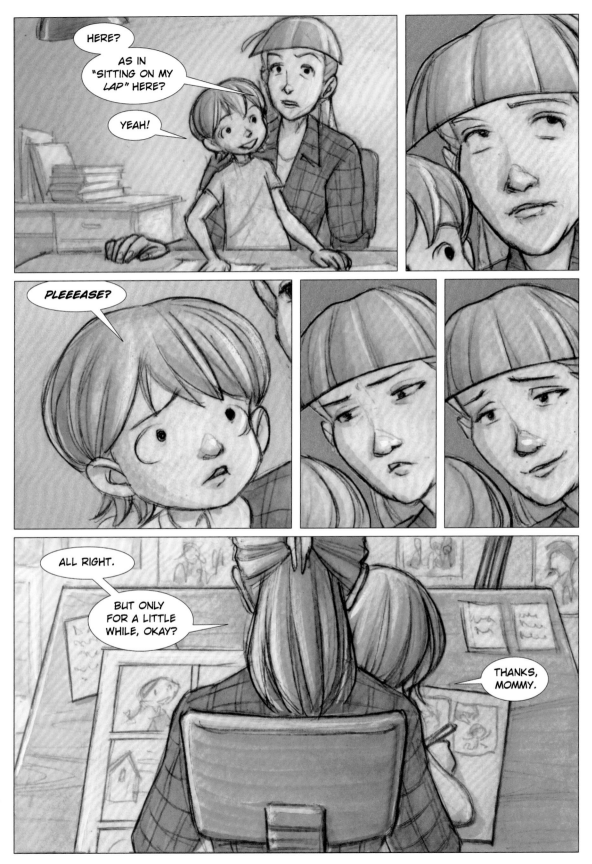

THE END

NOW IT'S YOUR TURN

When it comes to learning how comic book storytelling works, there's no replacement for getting in there and trying it yourself. To help you do just that, here are a few tasks you can undertake to begin creating comics of your own.

1. JUST A COUPLE OF PANELS

Let's start with something easy: a basic two-panel sequence. Try drawing a couple of panels, side by side, in which we see some sort of simple action take place. Having trouble thinking of what to show in your panels? Here are a couple of simple actions you could try:

- A woman opening an umbrella
- A boy peeling a banana, then taking a bite

2. A MULTI-PANEL SEQUENCE

Now let's take things to the next level by creating a sequence with more panels in it. Challenge yourself to portray a brief series of actions using at least five panels. If you like, you could stick with the same action you portrayed in your two-panel exercise, but this time expand it to include a bit of real storytelling. Here's how the two simple examples I gave could be expanded:

- The woman struggles to open the umbrella. We see the aggravated look on her face. Once the umbrella is finally open, she finds that there is a hole in it.
- The boy peels the banana and is about to take a bite when he sees his dog nearby, begging for food. He breaks off a piece and gives some to the dog.

3. CHARACTER DESIGN

Practice drawing a single character from different points of view. If you already have an original character that you draw regularly, challenge yourself to draw that character from a point of view that you've never attempted before. Here are some of the angles you could try:

- In profile
- Three-quarters

- From behind
- Bird's-eye view
- Worm's-eye view

Try to develop a system, as Trudy did for Emily, to make sure your character's face is consistent from one drawing to the next.

4. FACIAL EXPRESSIONS

Now it's time to draw your character in a variety of emotional states: happy, sad, angry, surprised, frightened, embarrassed, and confused. Focus on making full use of the eyebrows to convey each emotion. Try drawing the eyes wide open to make the character look more alert. Then try drawing the same expressions with the upper eyelids partially covering the irises, making the character look more relaxed.

EXTRA CREDIT: Comic book creators often need to show varying degrees of emotion. Take a single emotion and try conveying it at three levels: for example, a look of mild surprise, then one of full surprise, then one of total shock. See if you can do the same for all the various emotions.

5. DIALOGUE

Write a simple dialogue scene between two characters, limiting yourself at first to just putting it in written form. Then, take this script and translate it into comic book form, using as many panels as you feel are necessary.

If you're having trouble thinking of what the conversation should be about, here is a sample idea you could try:

- Characters A and B are looking at an abstract painting in an art museum. They begin to discuss what it's supposed to represent and find that their interpretations are surprisingly different.

When translating the dialogue from written form to comic book form, think carefully about which lines of speech should be in which panels, and which points of view will best serve the needs of the scene.

6. A WORDLESS SEQUENCE

Now that you've worked on your dialogue, set those skills aside and see if you can convey a sequence using only pictures. Use at least twelve panels to show what happens and have your sequence cover at least two pages.

If you're having trouble thinking of what sort of sequence to present, here's an idea you can use:

- Show a burglar sneaking into a house in the dead of night. Begin with them hopping a fence to get into the property, then show them scaling a wall and going across the roof to find a half-opened window. Show each step in the process as the burglar sneaks through the house, eventually arriving at the item they're planning to steal.

7. ENVIRONMENTS

Practice drawing a location. Once you've figured out the basic look of it, create a brief scene for one of your characters that takes place there. Be sure to include at least one big "wide shot" panel that shows as much of the setting as possible. Devote your energy to bringing the environment to life, giving readers a sense of what it would feel like to be in that space.

EXTRA CREDIT: Create an extended sequence in which a character moves from one sort of location to a markedly different one. For example, your scene could begin inside a cozy home interior. Then your character stands up, goes to the front door, and steps outside into a snowy or rainy environment.

8. A SERIES OF SCENES

Okay, this is it. It's time to get into the real fun of creating a comic book story, and that means creating multiple scenes, each one building upon the one that preceded it. If you already have an idea for a story, use that idea as your starting point. Here are a few tips to get you started.

Stories are hardly ever about the day that nothing special happened. Your second or third scene should introduce some unusual occurrence that gives your main character an opportunity to experience something new. They could be confronted with some sort of problem, or maybe they just meet someone they'd never met before. Let your imagination carry you from one event to the next. Ask yourself, "What could I make happen right now that will keep readers turning the page to see what happens next?"

Comic books are a visual medium, so make sure the story is told as much through the pictures as it is through the words. Beware of your story being overtaken by dialogue, or of having everything take place in the same location. Give your characters (and your readers) unfamiliar places to go, new things to see, and memorable sensations to experience.

Always go back and reread the pages you've just created, trying your best to experience them as the reader will. If something's not working, don't just leave it that way: Change it. Keep revising until everything flows smoothly from one panel to the next, and from one page to the next.

EXTRA CREDIT: Well, heck, if you can create a series of scenes, what's stopping you from creating an entire comic book? Go for it! See if you can get within the range of 20-to-24 pages. This is a standard length for a traditional American comic book. Make your work good enough, and there's nothing to stop you from having it professionally printed, just as Emily's comic was at the end of this book. And from there . . . well, take it from me: The sky's the limit!

9. CREATING A PUBLISHABLE COMIC BOOK

Several decades ago, there was a very standardized system for creating comics, but these days you are free to create your comic book pages using pretty much any art supplies you choose to. If a publisher loves the look of your artwork, they don't care which tools you used to create it.

In the end, the key to getting published comes down to things that are largely unrelated to art supplies or expensive software programs. Publishers are primarily interested in your story idea, and how engaging a storyteller you are. Come up with a killer idea, and then hone your story until you've created something that's so pleasing to the eye, and so enthralling to readers, that it's impossible to ignore. Do that again and again, and your work will eventually get the attention of publishers. I guarantee it.

Library of Congress Cataloging-in-Publication Data
 Names: Crilley, Mark, author.
Title: The comic book lesson : a graphic novel that shows you how to make
 comics / Mark Crilley.
Description: First edition. | California ; New York : Watson-Guptill, [2022]
Identifiers: LCCN 2021046509 (print) | LCCN 2021046510 (ebook) |
 ISBN 9781984858436 (trade paperback) | ISBN 9781984858443 (ebook)
Subjects: LCSH: Comic books, strips, etc—Technique. | Comic books, strips,
 etc—Authorship—Comic books, strips, etc.
Classification: LCC NC1764 .C75 2022 (print) | LCC NC1764 (ebook) |
 DDC 741.5/1—dc23/eng/20211109
LC record available at https://lccn.loc.gov/2021046509
LC ebook record available at https://lccn.loc.gov/2021046510

Trade Paperback ISBN: 978-1-9848-5843-6
eBook ISBN: 978-1-9848-5844-3

Printed in China

Acquiring editor: Kaitlin Ketchum | Project editor: Shaida Boroumand
Production editors: Ashley Pierce and Leigh Saffold
Art director/Designer: Chloe Rawlins
Typefaces: WildWords's by Comiccraft, Gotham by Hoefler&Co.
Production manager: Dan Myers
Copyeditor: Michael Fedison | Proofreader: Mark Burstein
Publicist: Lauren Kretzschmar | Marketer: Samantha Simon

10 9 8 7 6 5 4 3 2 1

First Edition